FEDERICO ZERI (Rome, 1921-1998), eminent art historian and critic, was vice-president of the National Council for Cultural and Environmental Treasures from 1993. Member of the Académie des Beaux-Arts in Paris, he was decorated with the Legion of Honor by the French government. Author of numerous artistic and literary publications; among the most well-known: *Pittura e controriforma*, the Catalogue of Italian Painters in the Metropolitan Museum of New York and the Walters Gallery of Baltimora, and the book *Confesso che ho sbagliato*.

Work edited by FEDERICO ZERI

Text
based on the interviews between
FEDERICO ZERI and MARCO DOLCETTA

This edition is published for North America in 2000 by NDE Publishing*

Chief Editor of 2000 English Language Edition
ELENA MAZOUR (*NDE Publishing**)

English Translation
SUSAN SCOTT

Realization
ULTREYA, MILAN

Editing
LAURA CHIARA COLOMBO, ULTREYA, MILAN

Desktop Publishing
ELISA GHIOTTO

ISBN 1-55321-015-8

Illustration references

Alinari Archives: 42-43.

Bridgeman/Alinari Archives: 1, 3, 4a, 8a, 8-9, 10, 10-11, 12a, 12-13, 18b, 35a, 36a, 44/XII, 45/X.

Luisa Ricciarini Agency: 15, 19, 26, 40as-ad, 44/ II.

RCS Libri Archives: 5, 6, 7b, 8b, 12b, 16b, 21, 22-23, 24-25, 30, 31, 32b, 34-35, 38b, 39a-b, 40b, 41a-b, 44/VI-VII-IX-XI, 45/II-VII-VIII-XIII-XIV.

R.D.: 2a-b, 4b, 7a, 11, 14a-b, 16a, 17, 18a, 20, 22a-b, 24, 27a-b, 28, 28-29, 32a, 33-a-b, 35b, 36b, 37, 38a, 42a-b, 44/I-III-IV-V-VIII-X, 45/I-III-IV-V-VI-IX-XI-XII.

Printed and bound by Poligrafici Calderara S.p.A., Bologna, Italy

* a registered business style of NDE Canada Corp.
15-30 Wertheim Court, Richmond Hill, Ontario
L4B 1B9 Canada, tel. (905) 731-1288

The captions of the paintings contained in this volume include, beyond just the title of the work, the dating and location. In the cases where this data is missing, we are dealing with works of uncertain dating, or whose current whereabouts are not known. The titles of the works of the artist to whom this volume is dedicated are in blue and those of other artists are in red.

MUNCH
THE SCREAM

"When the sun set, the sky suddenly grew blood red…
on the blue-black fjord and over the city were blood and
tongues of fire, my friends continued to walk along
and I was still trembling with fear – and I heard a great

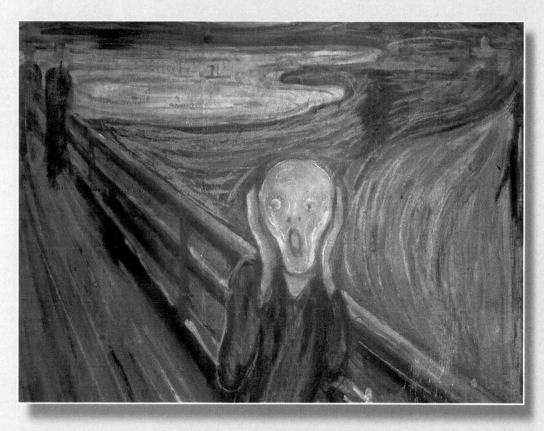

unending scream ring through nature." Thus Munch
wrote in his diaries before he painted THE SCREAM,
a work whose intensity carried Symbolism to
Expressionistic heights long before the *Fauves* and
the artists of *Die Brücke*.

THE GERM OF EXPRESSIONISM

THE SCREAM
1893

● Oslo, Nasjonalgalleriet (oil, tempera, and pastels on cardboard, 91x73.5 cm).

● Edvard Munch developed as an artist in the "Christiania Bohème" (now called Oslo), alongside Norwegian Naturalist artists like Thaulos and Krohg; in Scandinavia the examples of Courbet and Corot, already outmoded in their homeland, represented modernity to the decade of the 1870s. In 1885, Munch chose Paris as his new home. In the midst of constant trips all over Europe, the Berlin Exposition of 1892, in which he exhibited 55 works, made him famous outside of Norway, and his pictures on love and death provoked violent reactions from critics. The younger painters defended him; in opposition to official culture promoted by the Artists' Union, they founded the Berlin Secession. The master was by now welcomed and sought after in all the *salons*, where he became a friend of the writer August Strindberg.

● *The Scream* – a theme he repeated in more than 50 versions – shows its ties still to Symbolist culture in the effort to echo sound with color, the sense of desperate loneliness, and the elegant stylized lines of the landscape, but elements prefiguring Expressionism can already be detected. The vitality of the fluid yet aggressive symbol, which arrives at a deformation of the face and figure, making them almost amoeba-like, the looming presence of the diagonal of the bridge cutting through the waves in the background, the clear cross-references between the spaces, colors and symbols of the clouds are the innovative characteristics of *The Scream* and constitute the Norwegian master's signature style.

● In these soft, flowing lines, the passage is effected from the rhythmic modulation of Art Nouveau to the expressive force of the Expressionistic symbols striped with blood. The picture's greatness lies in its ability to condense into an image the world's power of persecution, no longer suggested, but now shouted.

◆ EDVARD MUNCH
(Löten 1863 – Ekely 1944)
As opposed to other northern European painters like the Swiss Ferdinand Hodler, Munch learned to use colors with skill and sensitivity from Manet. But it was Toulouse-Lautrec and especially the synthetic language of Paul Gauguin which helped him go beyond Impressionism to find a more incisive form, consonant with his use of line, heavily expressive and laden with meaning.

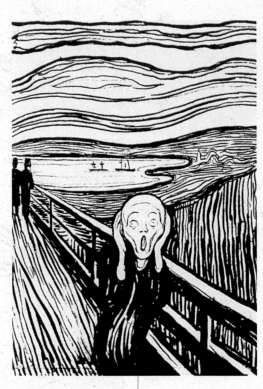

◆ THE SCREAM
(1895, Oslo, Munch Museet)
Munch's massive graphic production (some 15,000 pieces between works in color and black and white) is a way of exploring his recurrent themes using different techniques and colors. In the case of *The Scream*, the lithograph antedates the painting, which faithfully reproduces it. In 1894, he made his first etchings and lithographs; two years later he exhibited his first color lithographs and woodcuts. In this latter technique, the wooden block is cut away using a burin or blade, leaving in relief the lines to be inked for printing. Because of the expressive potential contained in the veins of the wood, the Expressionists used woodcuts extensively.

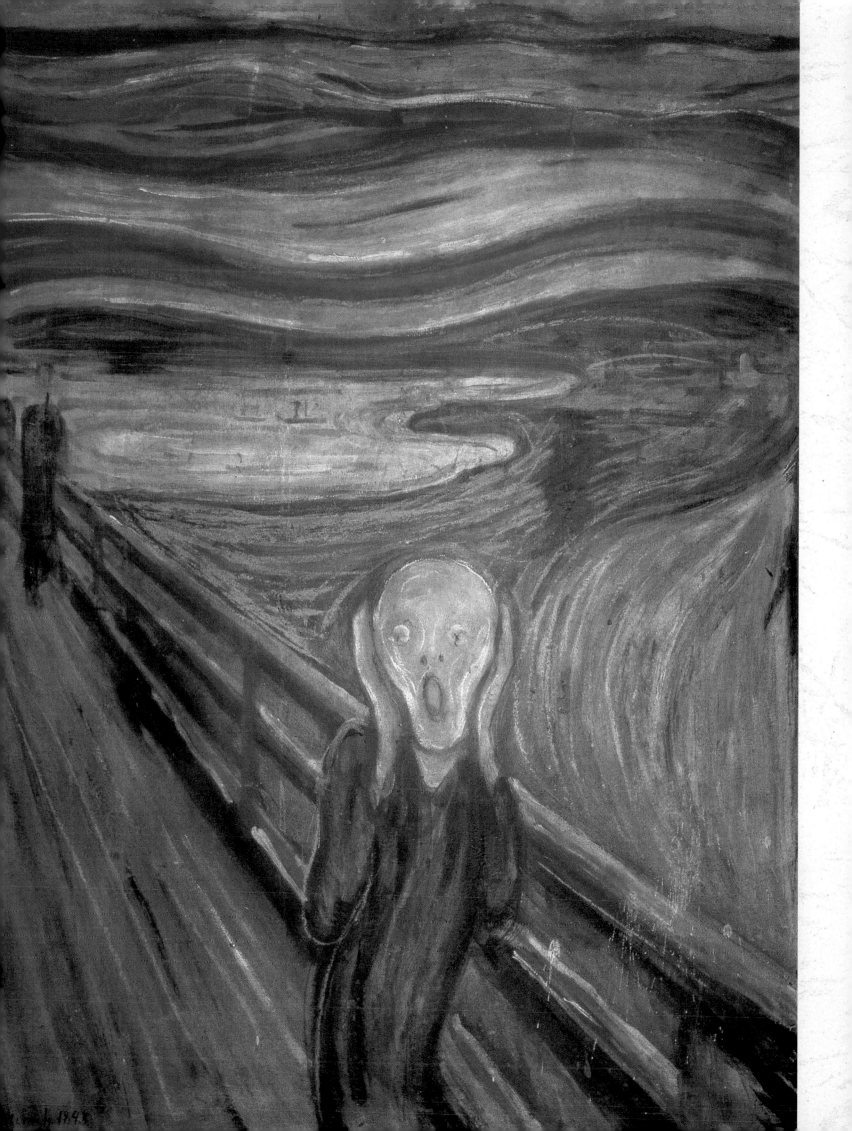

THE GENESIS OF THE WORK

It has been observed that the position of the hands in the figure in the foreground is the same as in other works by the master – such as *The Storm* and *The Dead Mother and the Child* – and derives, as the art historian Rosenblum has discovered, from a Peruvian mummy Munch saw in the Musée de l'Homme in Paris. It is a gesture in which the painter condenses the universal symbol of unbearable pain.

● The bay, with the insect-like sailboats, and the bridge edged by a railing indicate that the locale is Nordstrand. Some earlier pictures – *Evening on Karl Johann Street* and *Desperation*, both of 1892 – show the evolution of this work. The first study is a visionary transformation of a crowded street, such as the main thoroughfare of Christiania, into a spectral parade of ghosts. The faces, transfigured by the electric light into macabre apparitions, are stylized in a very similar way to the face in the foreground of *The Scream*; the figures seen from the back, walking against the flow and ignored by all, prefigure the loneliness of this painting. *Desperation*, painted a year earlier, describes the same situation: a sunset so red as to arouse fear, a man alone with his anguish, the same Nordstrand bridge, the same bay, and even the two boats. But here the landscape is narrated pictorially with rapid, chaotic, scythe-shaped brushstrokes, while in *The Scream* it is experienced as tragedy. The sign, even

◆ THE SCREAM
The picture is cut diagonally by the three straight lines of the bridge railing, which suggests a receding perspective, while the wavy lines of the landscape seem to take their shape from the head of the threadlike figure.

◆ PERUVIAN MUMMY
(Paris, Musée de l'Homme, below). During the Inca dynasty, high-ranking Indios after death were drawn, mummified, and placed in caves for drying. The bodies were arranged in the fetal position and wrapped in hemp sacks.

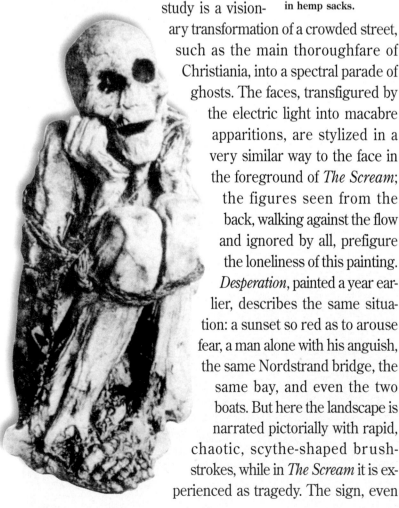

though organized in a rhythmic cadence, is more synthetic and incisive; the colors do not melt into each other but are heightened by juxtaposition in an atmosphere of mystical excitement.

● The idea of a great unending scream pervading nature was splendidly expressed by Munch in his diaries, written in Nice where he was hospitalized for rheumatic fever in 1891, thus before he composed this painting. His inspiration always had a literary root. The concept here is very close to the "great scream running through nature" illustrated in Heinrich Heine's *Twilight of the Gods* (1888), which must have had a deep impact on Munch's sensibility: the German phrase is inscribed on one of his variations of this work.

◆ THE DEAD MOTHER AND THE CHILD
(1899-1900, Bremen, Kunsthalle Bremen). This is in a certain sense an autobiographical work, a sort of commemorative portrait of his sister Sophie at the age of 6 – at the time of her mother's death – as she covers her ears in a child's typical gesture of refusal.

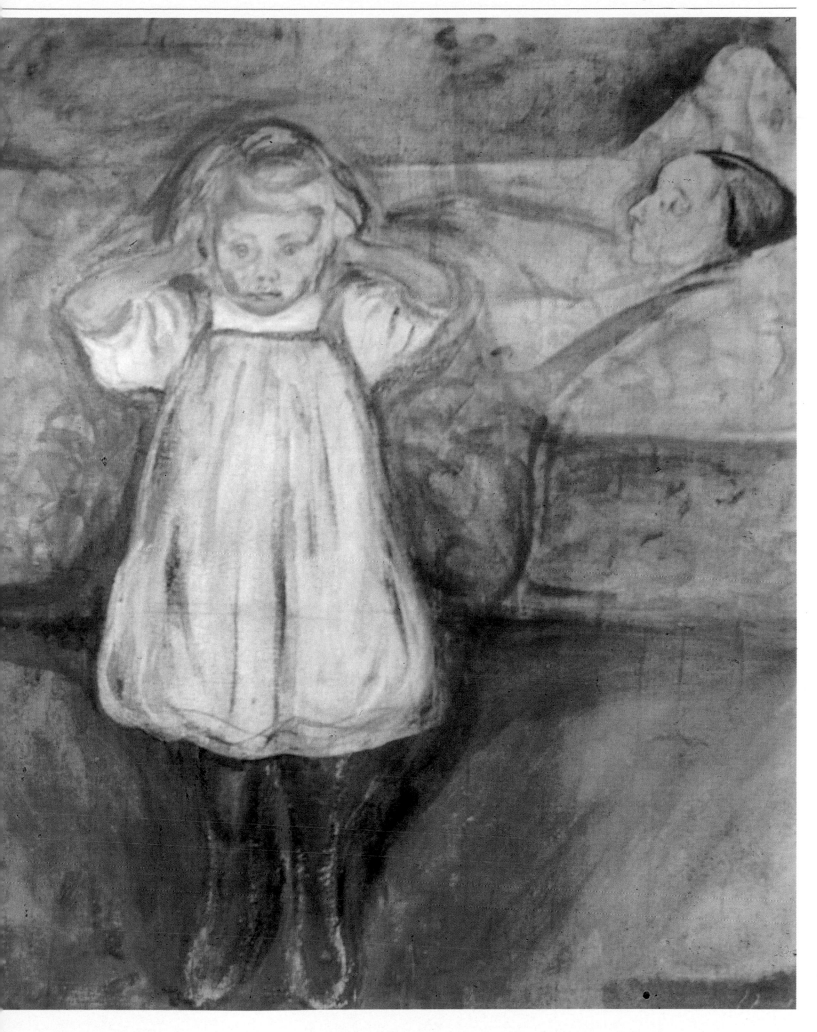

◆ EVENING ON KARL JOHANN STREET (1892, Bergen, Rasmus Meyer collection). The lighted window has a strong symbolic meaning for Munch, who sees it as a diaphragm between the inner and outer world, but it also has pictorial value in itself as a small abstract picture. These two expressive references fascinated the artist, who adopted the window as a personal trademark. The widely dilated eyes of the figure in *The Scream* may carry the same meaning.

◆ DESPERATION (1891, private collection). This watercolor, charcoal, and tempera preparatory sketch for the 1892 Stockholm painting shows that the iconography for *The Scream* is almost completely defined: all the elements are already there except the figure in the foreground, still seen as a man in profile and not as a larval presence.

◆ THE STORM (1893, New York, Museum of Modern Art) The gesture of covering one's ears, common to all the figures in this painting, is a universal sign of pain. Inner suffering arises from the depths and is echoed in the lyricism of nature. We do not know what these people are fleeing, what tragedy is taking place in the lighted house behind them, but the scene is immersed in the atmosphere of Ibsen's bourgeois dramas, which reveal a sensibility close to that of Munch.

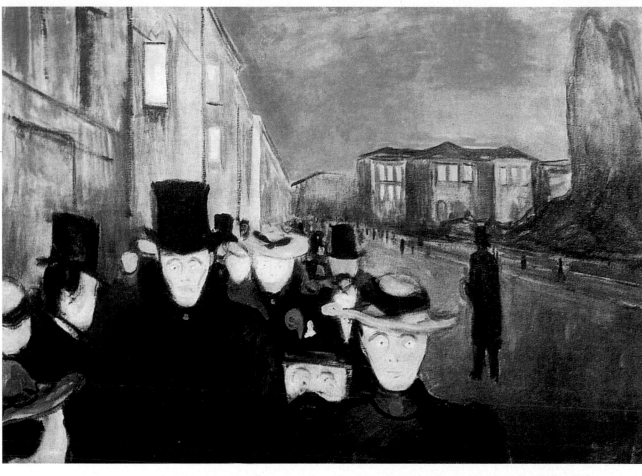

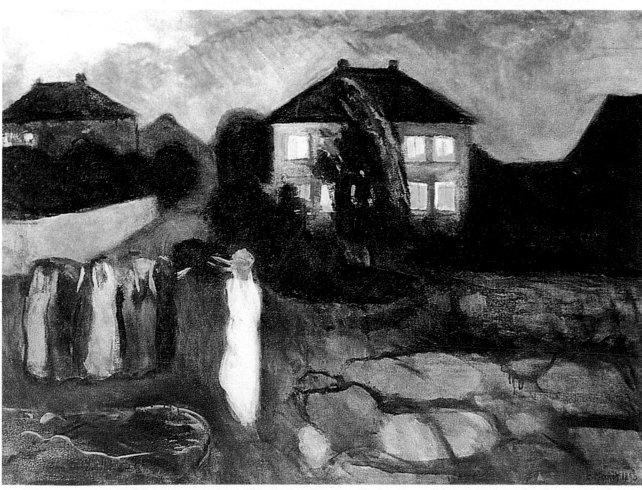

THE SCREAM OF THE COLORS

"I painted the clouds like real blood. The colors were screaming." The idea of a synesthetic involvement of the senses – in particular of hearing – in painting appears in Munch's work, as well as in that of artists contemporary to him like Klimt; but the optimistic, lyrical spirit of the Viennese master is completely overturned in the pessimistic vision of the Norwegian.

● The colors of the landscape are spread on the canvas like sound waves moving from the back of the painting toward the viewer. The bridge and railing, instead, are indicated with straight lines in perspective which penetrate the landscape, leading the eye into the painting's depth, where two figures with their backs turned, who do not hear or turn towards the screaming man, testify to the measure of his heart-breaking loneliness. His scream is an inner event which the others cannot hear; just the painter, as the only aware being, hears it so loudly that he has to cover his ears. Here returns the Romantic idea of an inner landscape and of nature animated by a divine spark, which only the artist in his loneliness or madness can perceive. He feels all the pain of the world (*Weltschmerz*) and suffers from a cosmic anguish.

● In the sky striped with blood, the version of *The Scream* in the Munch Museet shows a blue eye opening like a symbolic eye of God. But it is a vision that is anything but reassuring: the sky oozes blood, and part of the red river flows across the landscape, where two red bands join the green of the fjord's coast. The head, in the shape of a skull, seems to give birth to the earth, which appears almost to emerge from the skull like a dark shadow widening in encircling coils. The outer environment is a projection of the self, but precisely in this exteriorization can be perceived something terrifying.

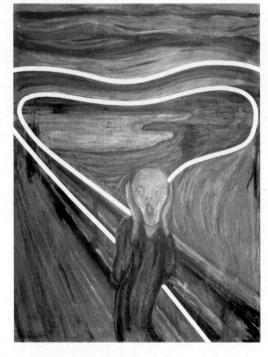

◆ TERROR AND DISMAY
His shout freezes in his throat, and just as frozen appears this creature, who seems emptied out, paralyzed. It is a soundless cry: silence can sometimes be so complete as to wreak havoc on hearing. The words Nietzsche puts in Zarathustra's mouth (1883-84) come to mind: "Yesterday toward evening my *voiceless hour* spoke to me, this is my mistress's name... I had never heard such silence around me, so that my heart was terrified. Then I heard someone speaking to me without a voice... And I screamed in terror at this whisper, my face blanched, but I was silent." The terror of which the philosopher speaks is the same existential panic gripping the creature here: torment and impotence before the ghosts peopling the unconscious.

◆ THE SCREAM (1893, Oslo, Munch Museet). This version in tempera on wood, slightly smaller than the one in the Nasjonalgalleriet, presents some variations of color and line, here slightly more sinuous. The dark patch of the landscape is like a shadow growing out of the figure itself, as in *Self-portrait in Hell*.

8

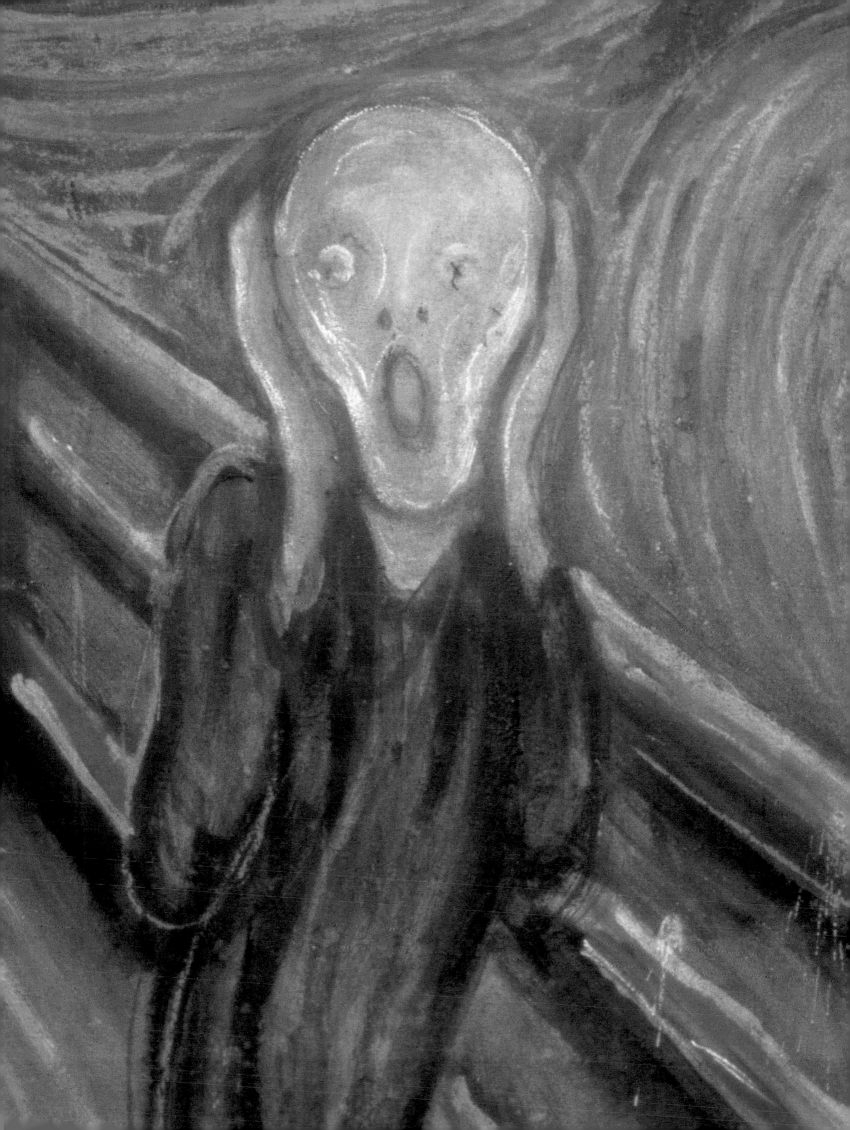

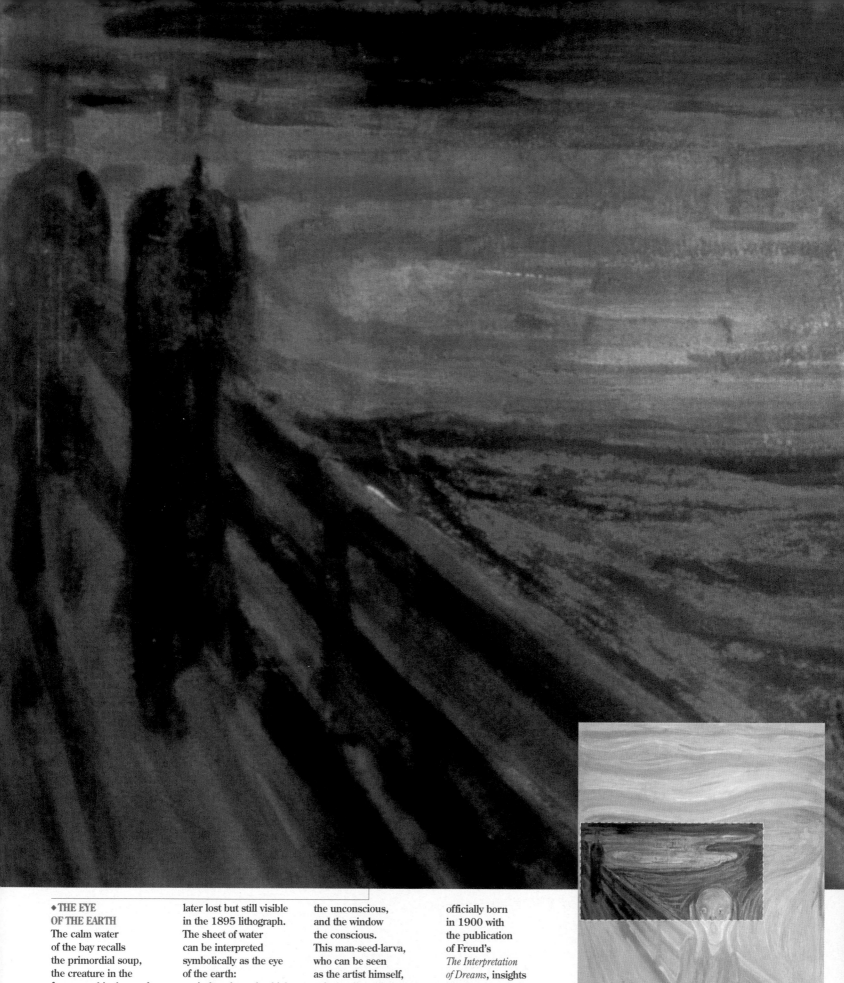

◆ THE EYE
OF THE EARTH
The calm water
of the bay recalls
the primordial soup,
the creature in the
foreground is the seed;
its shape resembles
the sperm the artist
painted on the left
of *Ashes* or on
the frame of *Madonna*,

later lost but still visible
in the 1895 lithograph.
The sheet of water
can be interpreted
symbolically as the eye
of the earth:
a window through which
the mysterious
underground forces can
observe the life of men.
The region of
the invisible is

the unconscious,
and the window
the conscious.
This man-seed-larva,
who can be seen
as the artist himself,
refuses all mediation
between self and reality
and flees from his
unconscious in horror.
Even though
psychoanalysis was

officially born
in 1900 with
the publication
of Freud's
*The Interpretation
of Dreams*, insights
into the sexual origins
of neurosis were
already being
expressed in art
at the end of
the nineteenth century.

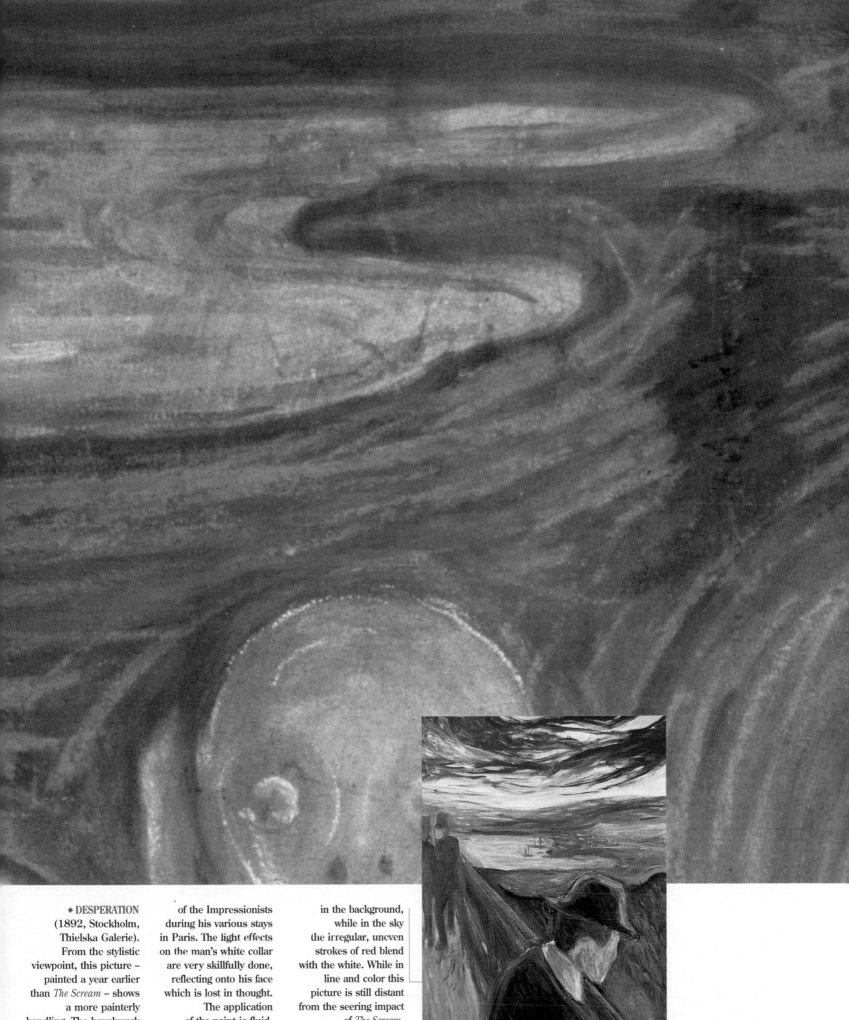

◆ DESPERATION
(1892, Stockholm,
Thielska Galerie).
From the stylistic
viewpoint, this picture –
painted a year earlier
than *The Scream* – shows
a more painterly
handling. The brushwork
shows that Munch had
absorbed the lesson of the Impressionists
during his various stays
in Paris. The light effects
on the man's white collar
are very skillfully done,
reflecting onto his face
which is lost in thought.
The application
of the paint is fluid,
with liquid effects
in the two men in the background,
while in the sky
the irregular, uneven
strokes of red blend
with the white. While in
line and color this
picture is still distant
from the seering impact
of *The Scream*,
their structure is already
quite similar.

◆ ANGUISH
(1894, Oslo,
Munch Museet).
The picture,
painted a year after
The Scream, shows
the same landscape,
stylization, and
conception of color in
terms of its expressive
possibilities.
The haunted faces recall
those in *Evening on Karl
Johann Street*, which
Munch describes in his
diary written in Paris:
"I was on the Boulevard
des Italiens... with
thousands of unfamiliar
faces who in
the electric light
looked like ghosts."

◆ THE FOUR ELEMENTS
The painting contains
the four elements:
earth, air, fire
(in the flames
making up the clouds),
and water.
The experience
of Van Gogh and
Gauguin is fundamental
for Munch: while he is
close to the former in
his treatment of
existential anguish,
he learned from
the latter the essential
formal style worked out
at Pont-Aven,
twisting its orderly
syntax, however, into
a hallucinatory tangle
of curved threads.

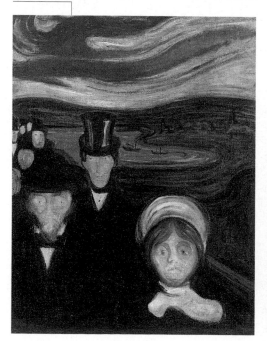

MUNCH'S BLACK ANGELS

"My pictures are my diaries," Munch wrote to explain the meaning of his works. In a pencil sketch of his principal theme, he wrote among the clouds "This could only be painted by a madman." *The Scream* is a man's raid on the world of madness; it expresses the laceration, present in Nordic culture from Romanticism to Existentialism, of the individual faced with the drama of life: "I inherited two of mankind's most terrible enemies: tuberculosis and mental illness. Illness, madness, and death were the black angels who kept watch over my cradle."

● The larval figure in the foreground has the value of an intense, dramatic self-portrait. The artist is on the borderline between illness, prophecy, and despair, the same despair that he felt at the death of his mother and sister, struck down by tuberculosis when he was still a child. This work, according to Munch, is born

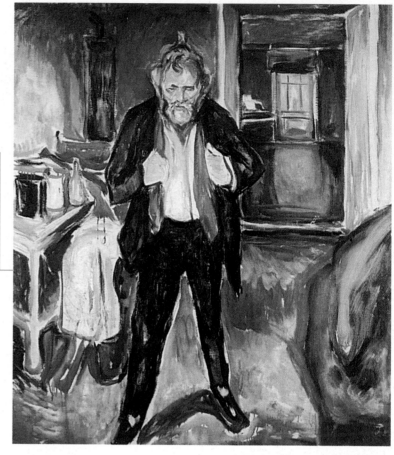

◆ SELF-PORTRAIT (INNER TORMENT) (1919, Oslo, Munch Museet). The inner anguish and doubts assailing the artist are infused into the painting in his anti-heroic stance and the dark colors. The figure, seen frontally, lacks any sign of self-celebration, and the inert pose of the arms betrays all of Munch's spiritual torment.

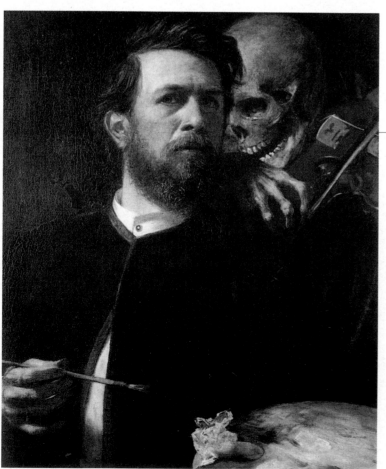

◆ ARNOLD BÖCKLIN *Self-portrait with Death Playing the Violin* (1872, Berlin, Nationalgalerie). The skeleton here acts as an admonition, a *memento mori* as in Counter-Reformation iconography.

out of estrangement and suffering. The same anguish of death which pervades his self-portraits can be seen in many works by German painters, like the *Self-portrait with Death Playing the Violin* by Arnold Böcklin, of 1872 – a work the artist admired – or the *Self-portrait with Love and Death* by Hans Thomas of 1875, or in that of Louis Corinth.

● Munch transposed into color the linearism of Art Nouveau. In *The Scream* the sinuous contour line, characteristic of the new style which spread throughout Europe toward the end of the century, seems to have been abolished. In reality, its flowing rhythm takes form in a perfect handling of the brushstroke, soft and concise, in the color which gives harmony to the stylization, in the sky, and in the screaming figure.

◆ SELF-PORTRAIT IN HELL (1895, Oslo, Munch Museet). In 1896 Strindberg wrote *Hell*, the diary of his journey through madness. In 1909, hospitalized in Copenhagen for nervous crises, Munch wrote his poem *Alpha and Omega*, illustrated by 18 lithographs.

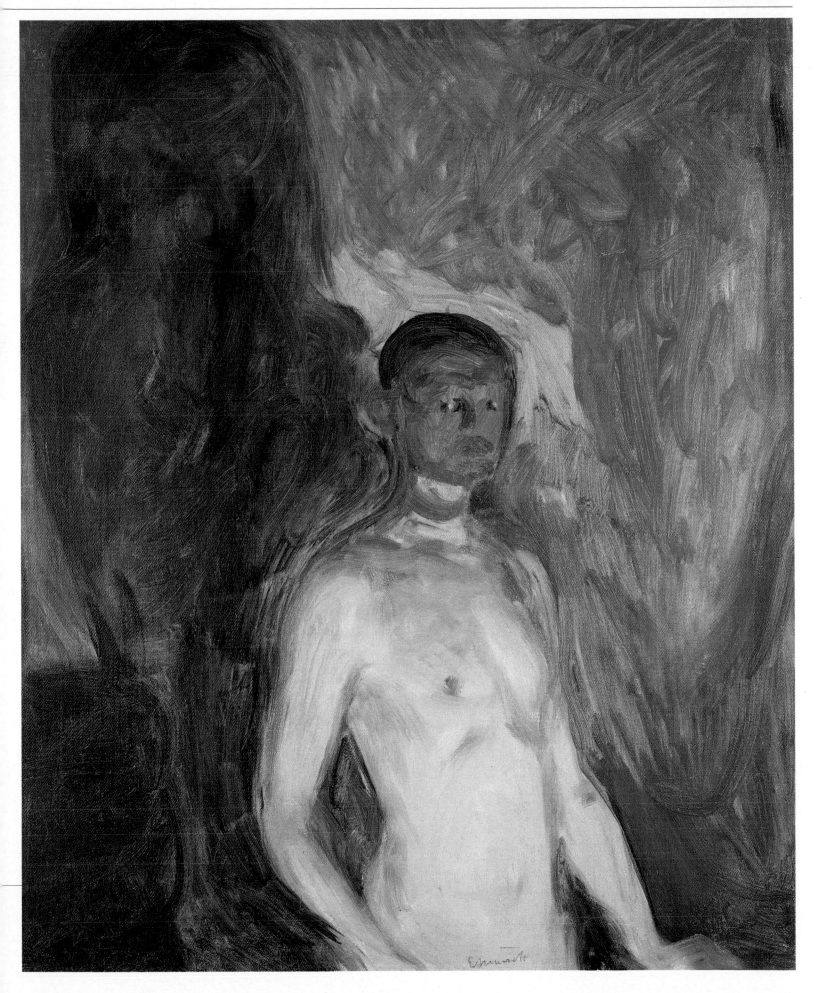

ALL THE ILLS OF THE WORLD ON THE ARTIST'S SHOULDERS

"In my childhood home lived illness and death": this was the painter's description of his childhood marked by a series of tragedies. His mother died of tuberculosis in 1868, when he was only five years old; then his sister Sophie died after a long illness. "Thus I lived with the dead… My mother my sister my grandfather and my father." His familiarity with sickness and the loss of family members made him feel all his life the emptiness and sense of mystery and precariousness of existence, and from this derives the atmosphere of anguish which imbues his work and the conjunction of love and death in his works treating of love.

● During his frequent trips to France, he absorbed the idiom of the Impressionists and the synthetic style of the *Nabis*, the group of artists gathered around Paul Gauguin who favored a

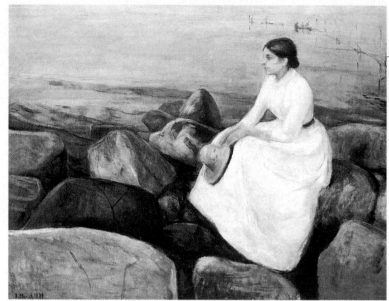

suggestive, antinaturalistic kind of painting, characterized by flat colors and the use of a contour line. But compared to the works of the French artists, Munch's are charged with an existential anguish. The tendency to pure colors which he learned from Serault contrasts with the mournful themes favored by the artist like *Sick Child, Death Enters the Room, Odor of Death*. "We can no longer paint interiors, people reading and women knitting, but living creatures who breathe and feel, suffer and love… People will understand that there is something sacred there, and will doff their hats as though in church."

● In Munch's work appears the idea, derived from Nietzsche, that the artist as a superior being is destined to bear the weight of all the suffering of humanity. This sensibility and a similar world view brought him close to Strindberg, with whom he also shared an attraction to the pathological, a persecution mania, an interest in metamorphosis, and difficulty in relating to the opposite sex. The two met in 1892 in Berlin, where Munch painted the writer's portrait.

● In 1896 the painter left Germany for Paris, where he found Strindberg again, who introduced him to French literary circles and reviewed his personal exhibition in the *Revue Blanche*, calling him "the esoteric painter of love, jealousy, death, and sadness." These themes, so clearly identified by the writer, were elaborated by Munch in the works comprising his series called the *Frieze of Life*.

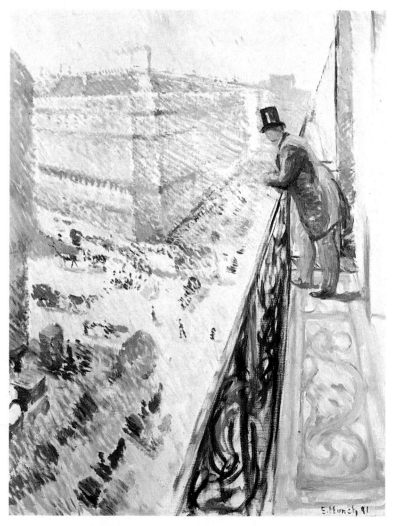

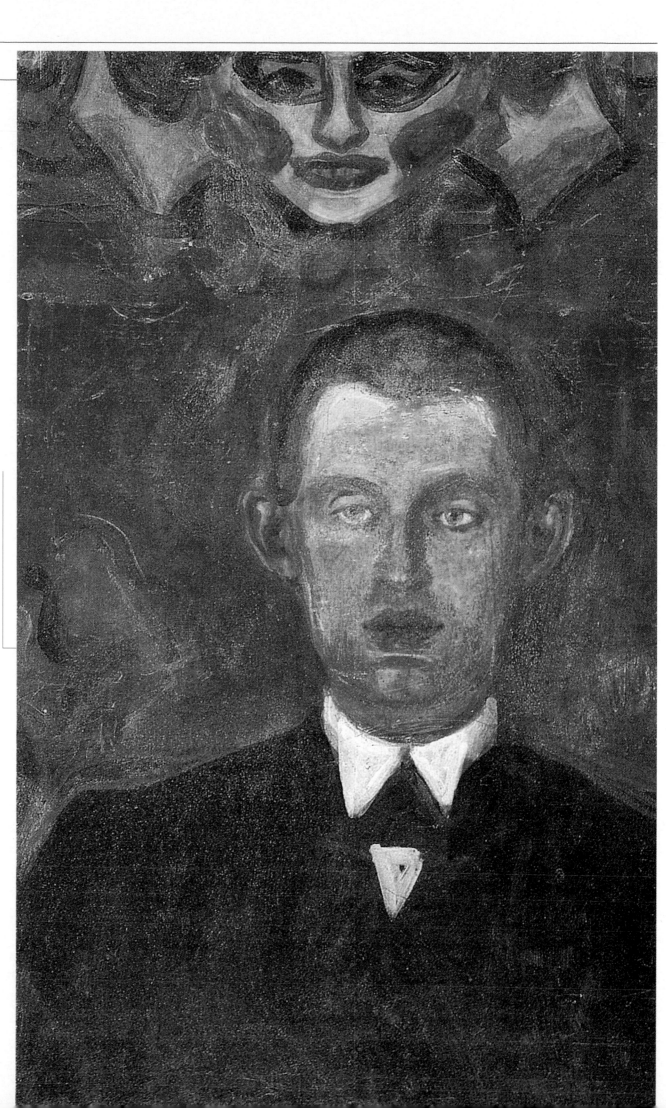

◆ SUMMER NIGHT
(INGER ON THE BEACH)
(1889, Bergen, Rasmus
Meyer collection).
This work demonstrates
Munch's invaluable
contribution to
the transition toward
a new kind of painting.
The figure and setting
are soaked in the intense
but indirect light of
Nordic summers.
The painter already
applies his idiosyncratic
compositional principles,
based on straight lines
and right angles,
and fully articulates his
favorite themes: solitude
and melancholy.
The work was attacked
by critics, who called
it a provocation
of the public.

◆ SELF-PORTRAIT WITH
A GORGON'S MASK
(1891-92, Oslo,
Munch Museet).
References to the formal
idiom of Gauguin
or Emile Bernard can
be found here. Inspired
by their painting style,
Munch abandoned
the Naturalism – with
just a hint of
Impressionism –
of his early works
for the symbolism
of his maturity.
The mask looming above
the painter is a Gorgon,
in evident psychological
relationship with him.
The Satanic
atmosphere recalls
Strindberg.

◆ RUE LAFAYETTE
(1891, Oslo,
Nasjonalgalleriet).
Like a shower
of raindrops made
of paint, the picture,
painted in Paris
during his brief stay
there in 1891, shows
the Impressionist
influence. Munch
already uses here
the motif of the railing
receding deep into
the picture.

MUNCH'S MISTREATMENT OF HIS CANVASES

Munch used to keep his finished works outdoors for a long time, exposing them to the elements. Only in this way, he would say, do they acquire a certain *patina* and dignity. His studio in the country at Ekely had a porch where the canvases were piled up; photographs show the garden strewn with pictures; friends tell of exhibitions of paintings hung on trees. This treatment, which it seems he himself called a "horse cure," was part of his creative process. Often it is very difficult to establish what damage is not deliberately sought and thus can be subjected to restoration; in effect, Munch's works also underwent mistreatment in their continual trips and moves. One thing the artist truly hated was varnish, often used by others to protect painted surfaces.

● The painting *Sick Child* is a milestone in Munch's art. In it are the seeds of his artistic procedures, from the technique of diluted paint – here used for the first time – to his habit of scraping and cutting into the dried pigment with a knife (perhaps a first step toward the "cure"), to his poetics of pain, illness, and death, to the idea that art must necessarily be autobiographical. In this work the painter takes time to tone down and flatten his colors: "I re-painted this picture many times during the year. I scraped it, I dilut-

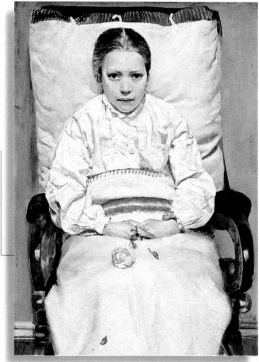

◆ CHRISTIAN KROHG
(1852-1920)
Sick Girl
(1880, Oslo, Nasjonalgalleriet).
In 1930 Munch wrote: "We lived in an era that I call 'the age of pillows.' Many painters showed sick children against the background of a pillow." Krohg here achieves monumentality by using a fully frontal position.

◆ THE PAINTER IN HIS OPEN-AIR STUDIO AT EKELY
The photo shows the painter next to his canvas *Sun* hanging by a nail. His actual use of the expression "horse cure" is not documented, but the drastic mistreatment of his canvases gave evident results. A visitor told of seeing his paintings, exhibited in a courtyard, being covered with snow.

ed it with turpentine, I tried numerous times to recreate the first impression – the transparent pale skin against the canvas – the trembling mouth – the trembling hands… I scraped about half, but I left some paint. I thus discovered that my eyelashes took part in my first impression. I suggested them as shadows on the painting."

● When oil paints started being produced commercially, oil colors began to be used without any preparation which could tone down their glare, on canvases which also were factory-made and pre-prepared. All this made Munch's colors too loud. The artist, to obtain his dry, dull images, began in 1892 a series of experiments, including casein-based paints, long used in art before the development of oils but which – as his works from the 1890s demonstrate – have the drawback of cracking on the painted surface.

● For each work, he made numerous studies: in pastel, tempera, oil, pencil, and the various engraving techniques. Five oil versions exist of *Sick Child*, dated 1885-86, 1896, 1906, 1907, and 1926, as well as lithographs and engravings. "If I take up a theme again and again, it is in order to submerge myself in it. An image cannot be exhausted in a single painting. Every version represents a contribution to the feeling of my first impression."

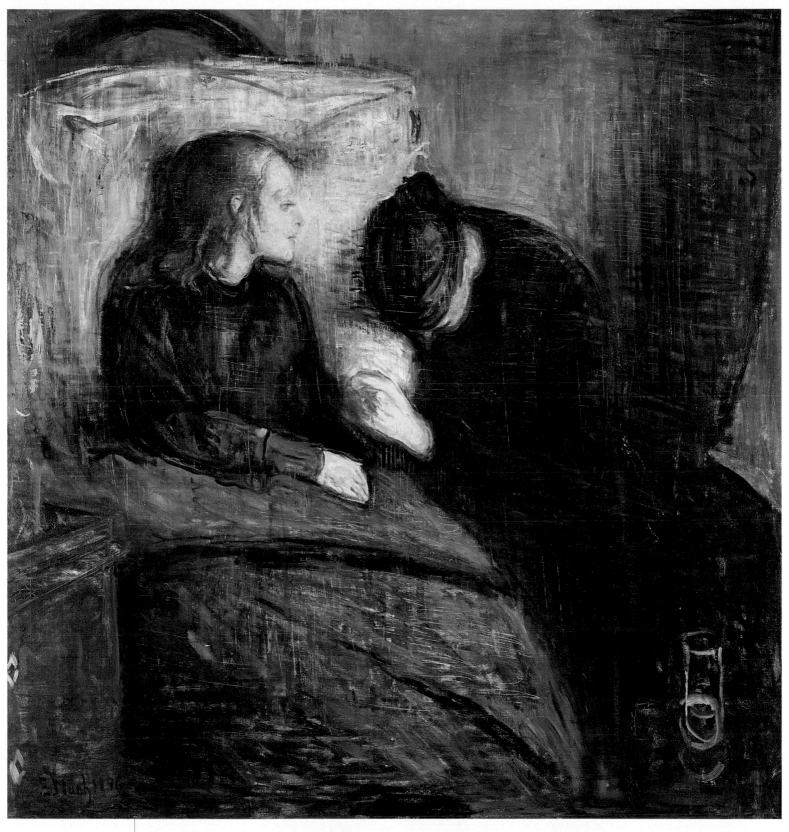

◆ SICK CHILD (1885-86, Oslo, Nasjonalgalleriet). "I don't believe that any painter has lived his theme until the last cry of pain as I did when I painted *Sick Child*... I was not alone on that chair as I painted, seated with me were all my loved ones who, beginning with my mother, had sat there, winter after winter, tearing themselves up in their desire for sunshine, until death came to get them." This painting, too, was received negatively by critics, who made comments in the press about the child's hand, calling it "fish paste in lobster sauce." Such hostility towards paintings that had not yet broken with tradition leads one to think that their criticism was addressed to all of the "Christiania Bohème" and its anti-middle class attitudes. The cowardice and hypocrisy of bourgeois society were attacked in those same years by the Norwegian playwright Henrik Ibsen.

1892: THE BERLIN EXPOSITION

On October 4, 1892, Munch was invited by the Berlin Artists' Union to hang a one-man show of 55 canvases in the new "Architektenhaus" gallery. The exhibition caused such an uproar with the public that the authorities were forced to close it. It was not the German artists, as has often been said, who supported Munch. The group of young artists, with Max Liebermann as their head, who rebelled in 1899 against the academic traditionalism of the Union and founded the Berlin Secession, did not, with the sole exception of the painter Walter Leistikow, take a stand on Munch's works. The Berlin artists, in truth, were indignant only about their countrymen's bad manners: it was the first time that a foreign artist who had been invited by the Union was then forced to leave. It was instead the literary men who took the artist's side and understood immediately the great innovation he had introduced. In any case, these events, instead of eclipsing Munch's fame, made him a success, and the doors of the Berlin *salons* and intellectual and progressive circles opened to the Norwegian artist.

● While the show then traveled to Düsseldorf and Cologne,

the artist signed a contract with an art dealer, not for the sale of his canvases, as is usually the case, but to divide the proceeds of tickets to the exhibition, to which people flocked in droves to see "the scandalous works." In the meantime the artist rented a studio in Berlin, studied the works of Böcklin and Klinger, and came into contract with the entourage of the café *Zum schwarzen Ferkel* ("At the Black Pig"), composed of writers, artists, critics, and scientists. He became friends with the Polish writer, poet, and critic Stanislaw Przybyszewski – whose portrait he would paint two years later – and Strindberg, whose picture he also painted.

● The Berlin period saw the birth of paintings like *The Scream*, the first version of *Separation*, and the *Woman in Three Phases*, a monumental Symbolist work, in which woman is interpreted symbolically in her three stereotypes of whore, victim, and Madonna. But the question is certainly much broader, as the artist himself recognizes in a letter to Tulla Larsen, "I have seen many women who have thousands of changing expressions like a crystal, but I have never met any who in such a strange way had only three, but very pronounced."

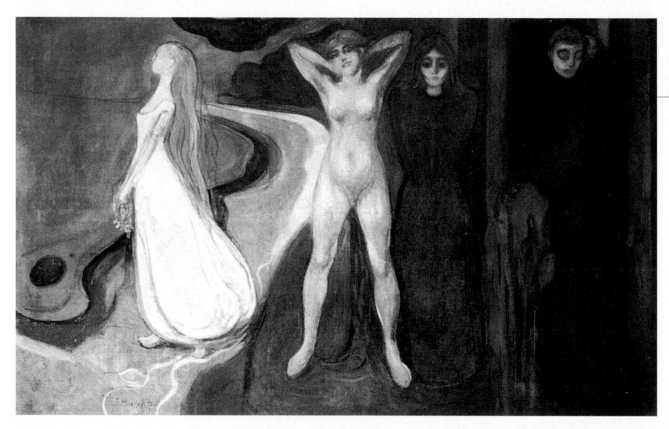

◆ WOMAN IN THREE PHASES (1894, Bergen, Rasmus Meyer collection). The work was shown in Stockholm with the subtitle: "all the others are one you are a thousand." In 1902 in Berlin it was placed in the center of the *Frieze of Life* with the title "Love that blooms and fades."

◆ MADONNA (1894-95, Oslo, Munch Museet). The *Madonna* or *Woman who Loves*, as Munch's most famous work after *The Scream* has been called, does not swerve from the ambivalence typical of Symbolism. This *Madonna* wavers between Salome and Ophelia. Her halo has been read as Ashtarte's moon.

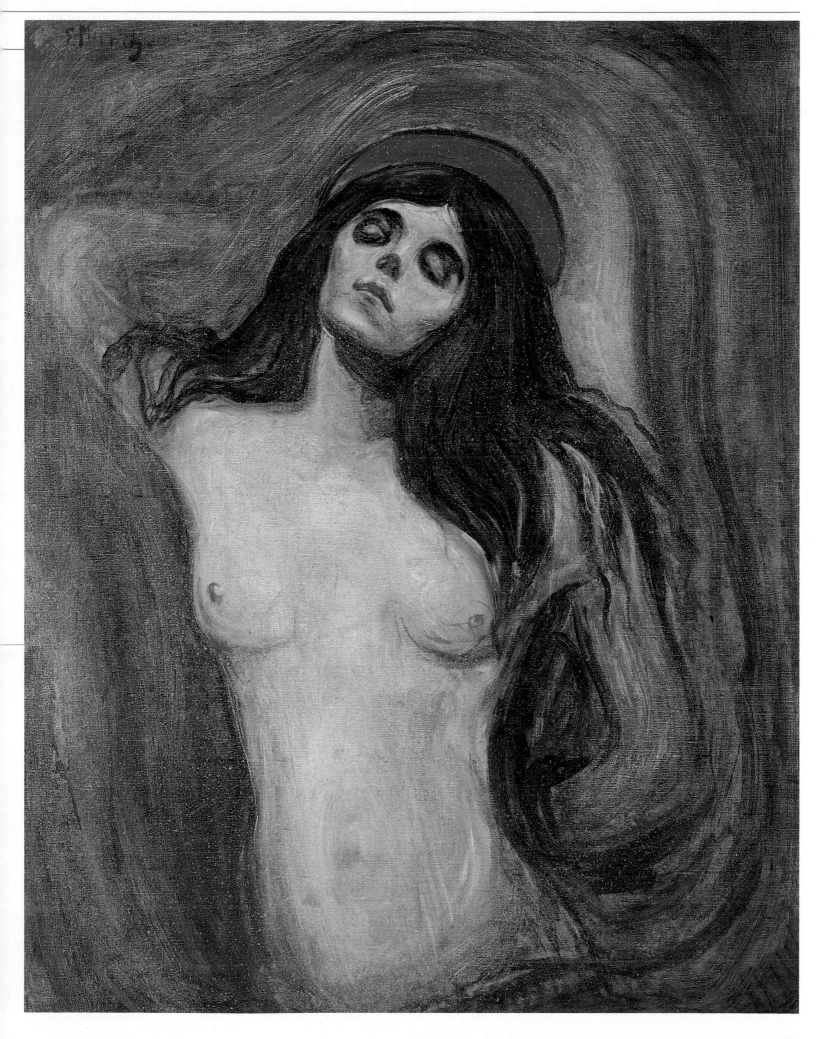

PRODUCTION: THE WORKS

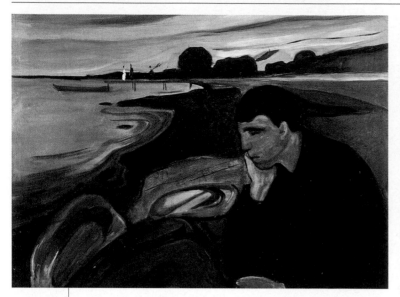

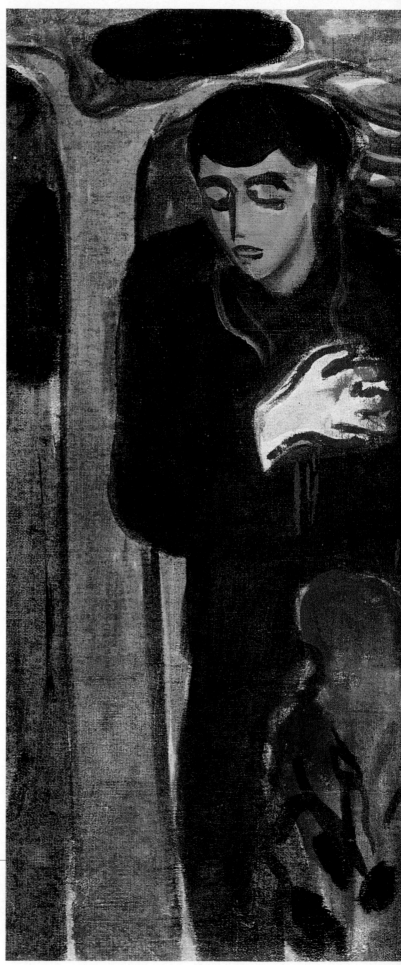

◆ MELANCHOLY
(EVENING)
(1894-95, Bergen,
Rasmus Meyer collection).
The iconography derives
from Max Klinger's
Evening, of 1899.
The man with a
helmet-shaped hairstyle,
posed as in Dürer's
Melancholy, is Munch's
self-portrayal as his friend
Jappe Nilssen.

◆ JEALOUSY
(1895, Bergen, Rasmus
Meyer collection).
"These paintings are
states of mind,
impressions of life and
the soul, and together
they represent an
aspect of the battle
between men and
women called love."
Thus Munch interprets

his paintings shown
in Berlin in 1895.
Jealousy, his first
Symbolist work,
was inspired
by the difficult
relationship
between his friend
Jappe Nilssen and
the wife of his
teacher, the painter
Christian Krohg.

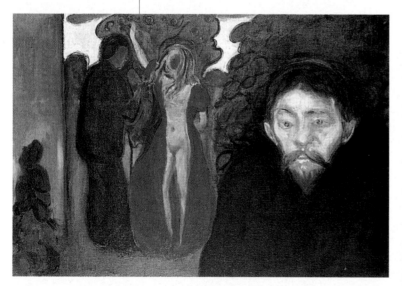

◆ SEPARATION
(1896, Oslo, Munch
Museet).
"... a long, empty
line of beach.
The woman's hair is
entwined and tangled
around his heart.
The man is truly
wounded in this
battle..." With these
words Munch explains
the painting in terms of
states of mind.

The woman dressed in
white who is moving
away – with an elegant
stylized profile echoing
the forms of
the Jugendstil – is
already present in other
paintings like *Woman in
Three Phases*. From
the Symbolist point of
view, the woman
corresponds to the sea
nymph who turns
toward the feminine

element of water and
away from man's reach.
The large blood-red
flower next to the man,
also present in *Woman
in Three Phases*, can be
identified as the "flower
of pain," seen against
the background of his
family's Christian piety.
The artist sees
his own suffering as
corresponding
to that of Christ.

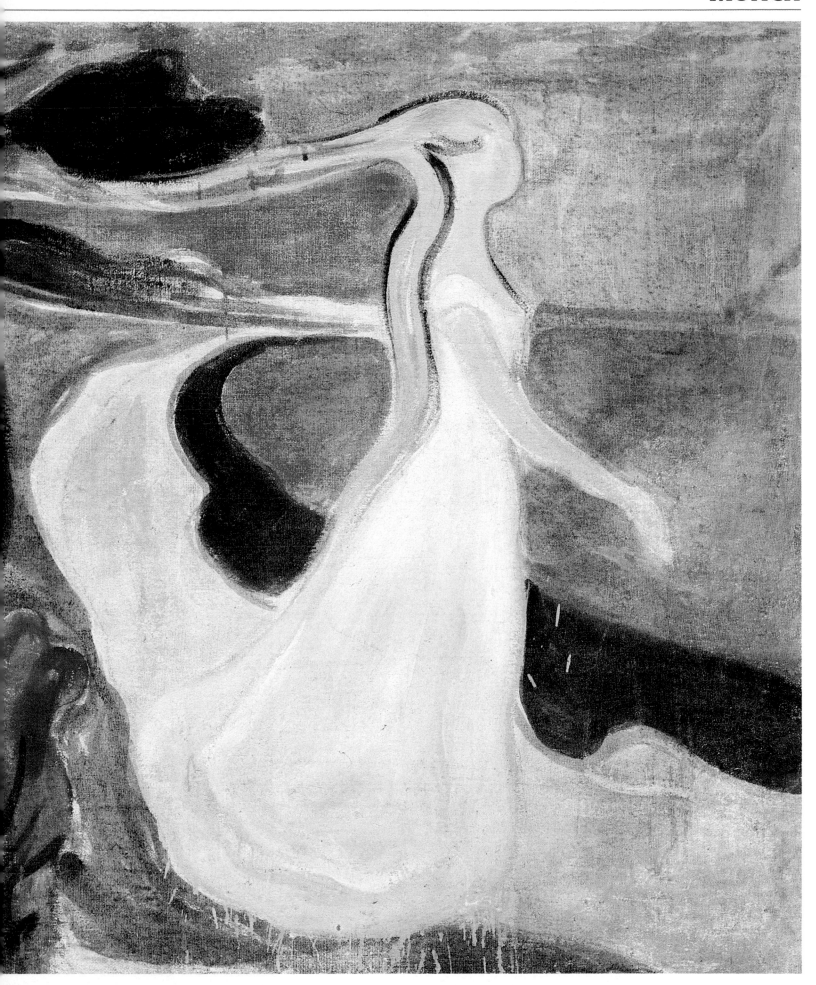

LOVE AND DEATH

"In the beginning was sex," Przybyszewski states in *Totenmesse* of 1893. Eroticism as a sickness of the soul was more or less deliberately presented in art. It is a view that in many ways prefigures the theories later codified by Freud in *The Interpretation of Dreams* (1900), in which eros lies at the base of neurosis.

● Sexual themes also invaded Munch's art; he took the theme of sexuality as the principal motive of art, the source of inspiration and the primary element of life. In Strindberg as well, the tension, struggle, and contrast between love and hate in the relationship between man and woman – which finds its origin in Nietzsche – becomes central. Ralf Stenersen, the painter's friend and biographer, states that "In the course of his life, Munch had numerous relationships with women, but all short-lived, and he was unable to recall any of

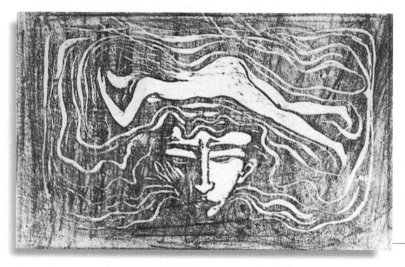

them with joy or gratitude. The more affectionate women were toward him, the more they must have intimidated him…"

● Munch, a young introvert, met Tulla Larsen in 1898 in Christiania, and immediately a blossoming love turned into conflict. They traveled together to Paris, Nice, Florence, and Rome, but the first problems soon arose: she wanted marriage, a family, a less bohemian existence. Munch took refuge in drink, refusing to rearrange his life. Tired, depressed, and sick, he fled from normality and from Tulla, deciding to have himself hospitalized. But when she wrote him from Berlin, asking for help, Munch yielded. After this fleeting reconciliation, the couple lasted two more years, but a violent and dramatic fight, during which Munch wounded himself in the hand with a gun, ratified their final separation, and a year later Tulla married the young painter Arne Kavli.

◆ VAMPIRE (1893-94, Oslo, Munch Museet). Munch would frequently say that "Art feeds on the artist's blood." The *femme fatale*, woman as vampire, is an obsessive image in his paintings, thus for Munch she is the essence of art itself. This dome-shaped composition is shaped by the blood-red streaks of the woman's hair, which stream down to wrap the man in a fatal embrace. "Munch has already introduced in his lines this destructive violence of terror," the poet Rainer Maria Rilke (1875-1926) stated in a letter.

◆ IN MAN'S BRAIN (1897, Oslo, Munch Museet). The female mask hanging menacingly over the painter's head in his self-portrait of 1891-92 here materializes as a female body, like a worm tunneling its way through the meanders of the mind. While the self-portrait with the mask partakes of a Symbolist climate close to the manner of Gauguin and Emile Bernard, this is Munch's manifesto of painting, the expression of an artist who more than any other was able to give a face to the modern psyche and its neuroses.

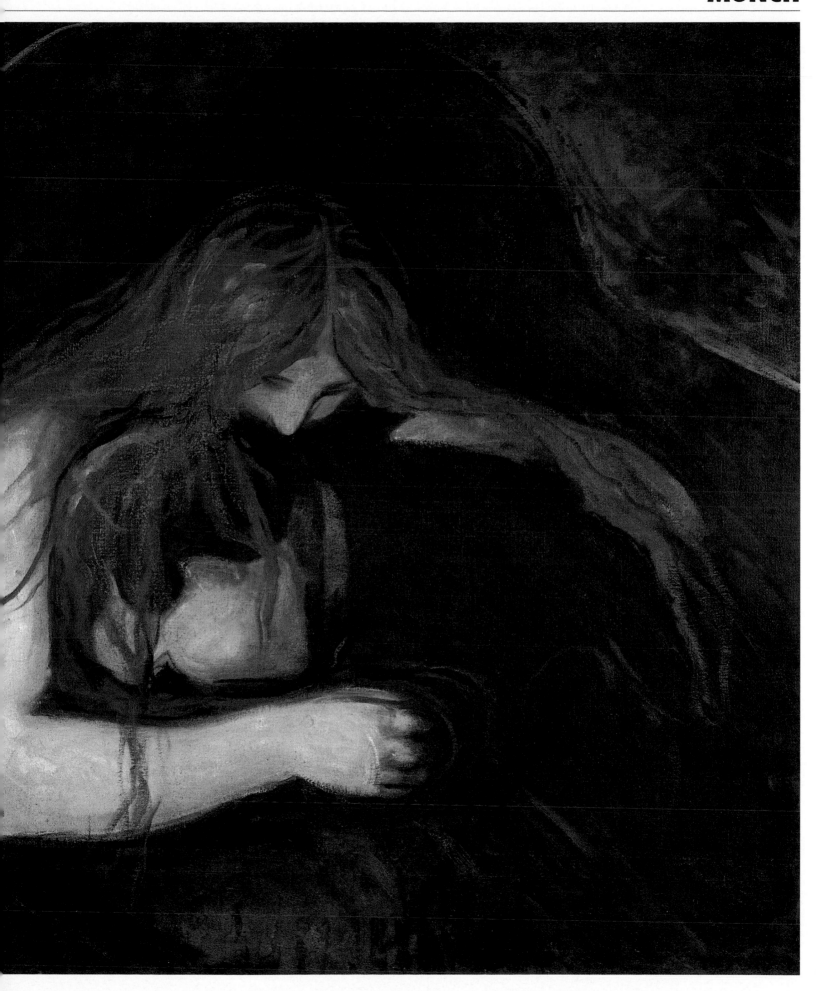

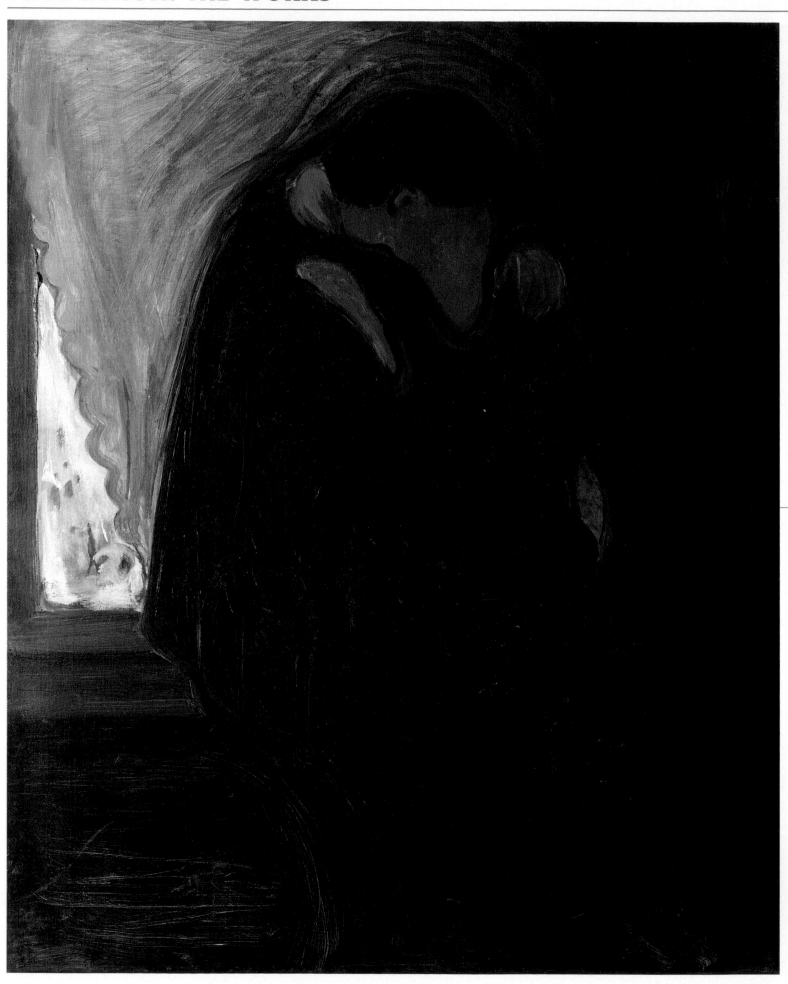

◆ ASHES
(1894, Oslo, Nasjonalgalleriet). The simplification of the composition resembles a stage set, where the dark background is marked off by slender tree trunks. The dramatic gestures of the figures as well recalls the theater. The fallen trunk transformed into ashes and seeds in the foreground can be ideally connected with the *Self-portrait with a Skeleton's Arm*. In terms of the biographical value of Munch's works, here we can read a reference to the break-up of his relationship with Tulla Larsen.

◆ THE KISS
(1897, Oslo, Munch Museet). The painting expresses the fatal attraction between the sexes. Przybyszewski gives an evocative description of the work: "We see two human figures whose faces melt into each other. Not one facial feature can be recognized: all we see is the point of fusion, in the shape of an enormous ear that in the ecstasy of the blood has grown deaf. It seems like a puddle of liquid flesh."

◆ THE NEXT DAY
(1894-95, Oslo, Nasjonalgalleriet). The painting, with its eloquent title, is linked ideally with the *Madonna*, next to which it hung in the Berlin exhibition of 1892. The composition is balanced by the calm flow of the curves of the mattress and the leg. The colors harmonize around tones of ochre and brown, reaching the luminous point of white in the woman's loosened bodice.

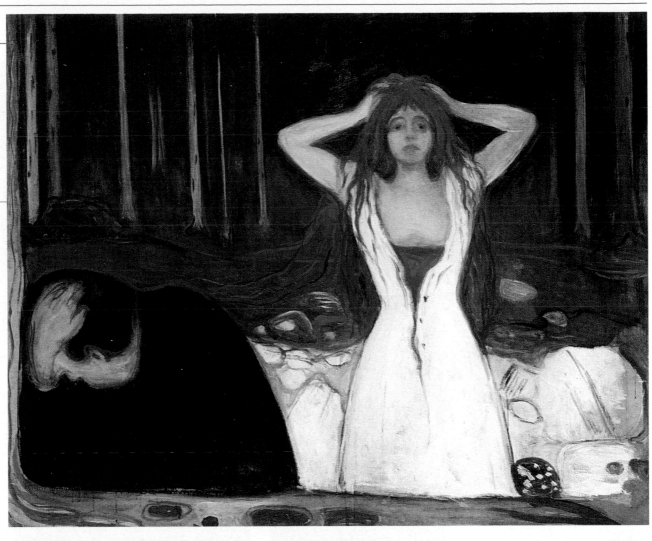

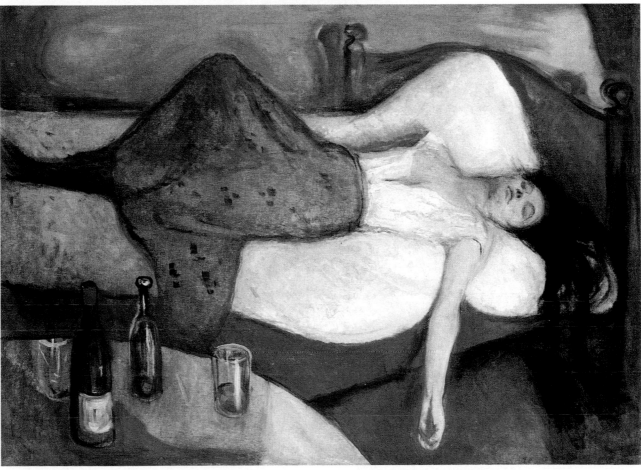

PRODUCTION: THE WORKS

♦ THE DEATH OF MARAT (1907, Oslo, Munch Museet). The accident involving his hand and his break with Tulla are recurring biographical elements in the painter's work, in his vision of the relationship between man and woman as struggle and eternal conflict. Tulla's features can also be detected in the figure of Charlotte Corday here, where the historical event is just a pretext for Munch to evoke again the tormented end of his love affair. The view of woman as vampire returns, the murderess who, like the praying mantis, kills the male after coupling. The obsessive image of the woman who devours men coincides with the declared misogyny of Strindberg, who in *Hell* – in a dialogue with his mother – states: "Women are our demons" and later affirms: "And woman is a double demon." The spare composition, around the vertical axis of the nude woman, and bright colors spread with violent Expressionistic brushstrokes accentuate the drama of the scene.

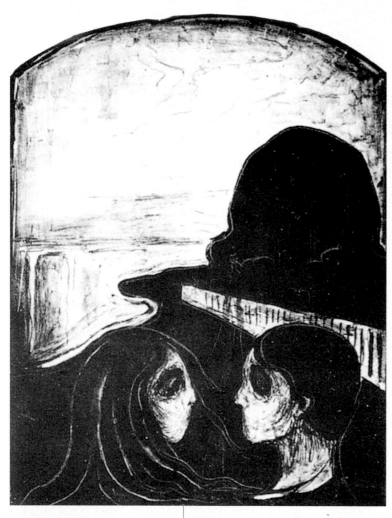

♦ ATTRACTION (1896, Oslo, Munch Museet). In a nocturnal landscape, a man and woman in profile face each other. Her hair wraps like tentacles around his neck, suggesting a beheading, perhaps that of John the Baptist requested by Salome, an image used so often by the Symbolists as to become a cliché. Their eyes are marked by dark, deep circles which prefigure death, the destiny of every love. The attraction between the sexes is seen as fatal. In two different writings Munch repeats the same lines to express the tie between love and death: "The pause when the world stops its course/ Your aspect contains all the beauty of the earth/ Your crimson lips like ripening fruit,/ Part as though suffering/ A cadaver's smile/ Now life holds out its hand to death/ The chain is closed that links a thousand generations/ of dead to a thousand future generations."

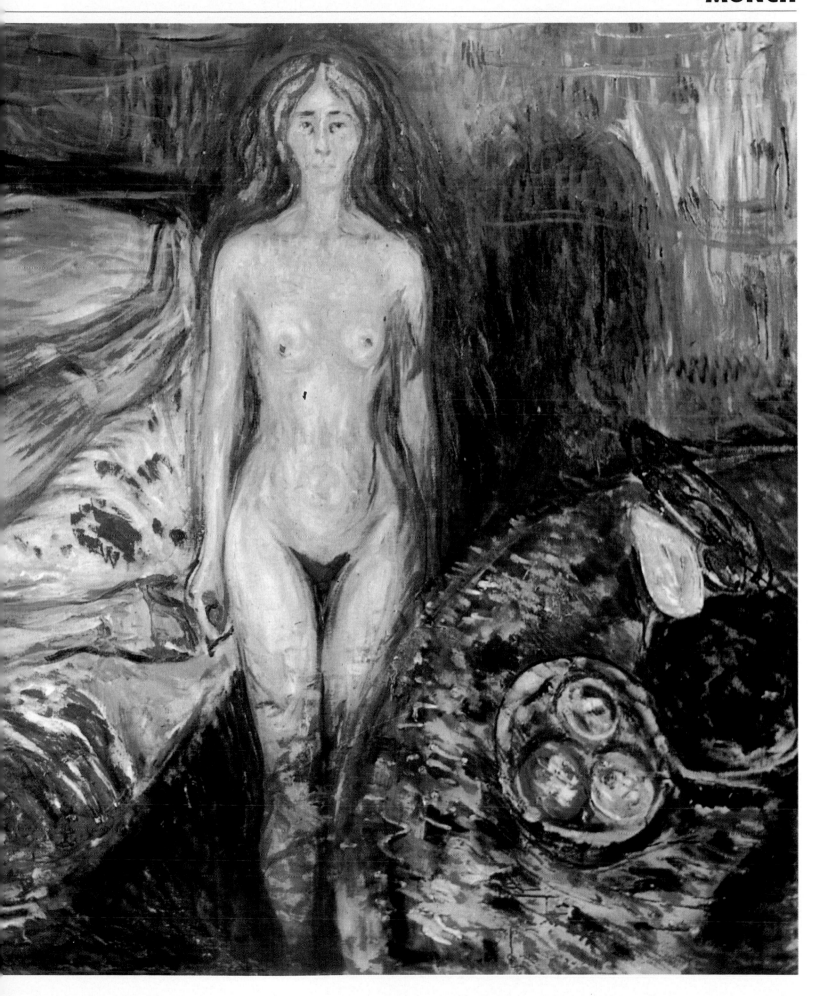

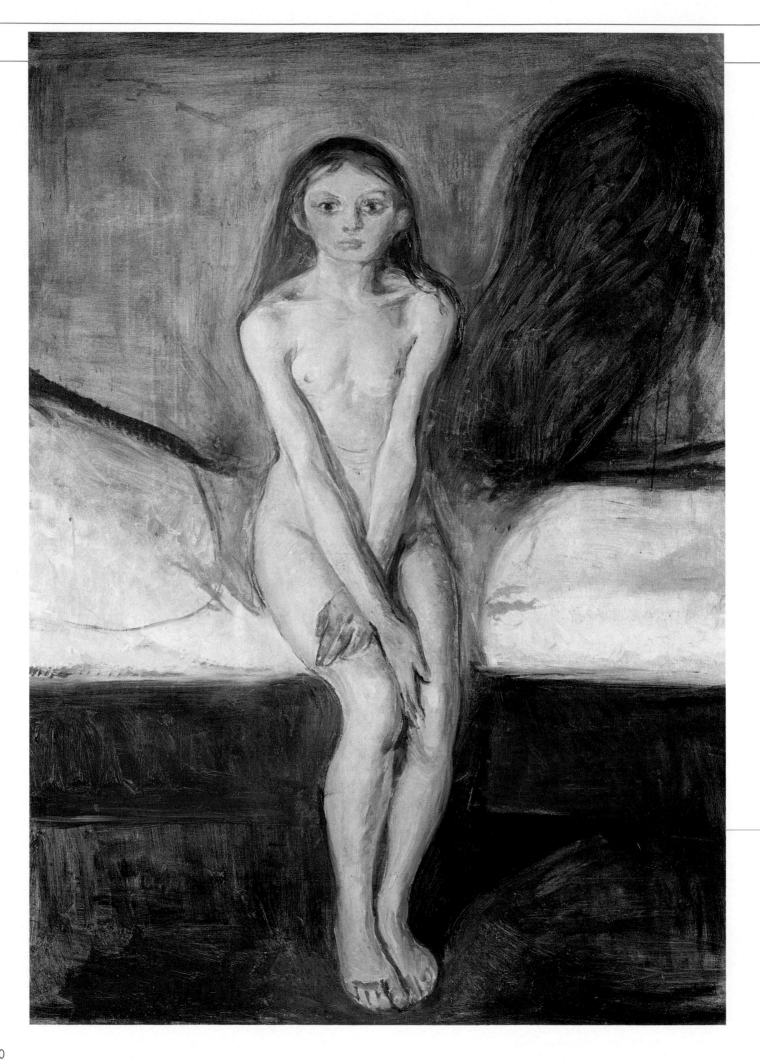

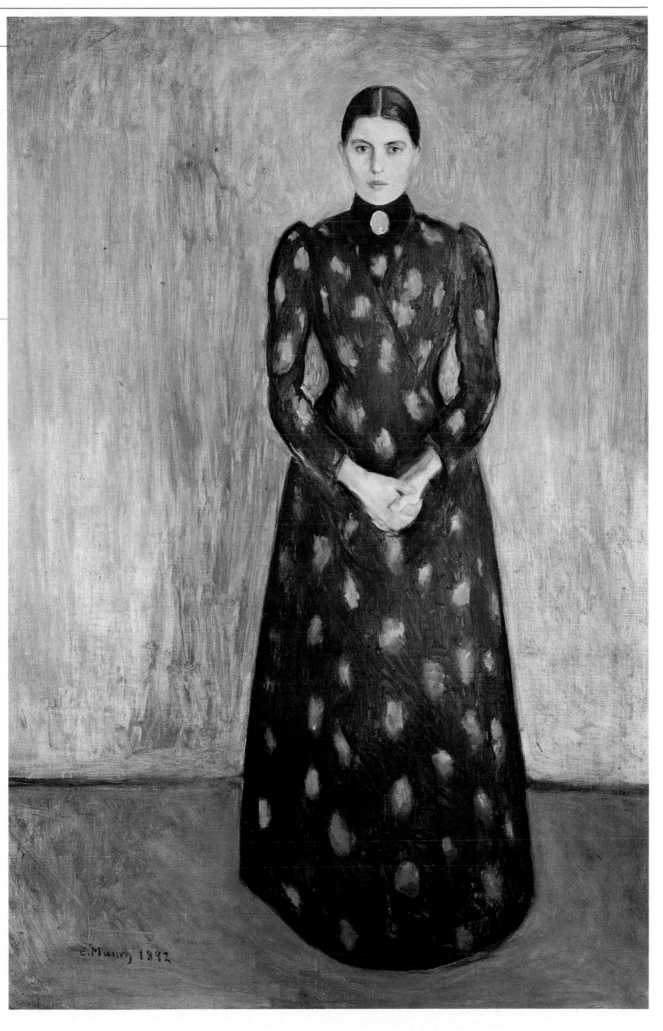

◆ PORTRAIT
OF HIS SISTER INGER
(1892, Oslo,
Nasjonalgalleriet).
The austere figure
of Munch's sister is
painted with
a simplification of form
close to the parallel
experiences of Klimt
and Hodler, but
he moves beyond
the rhythmic line
and refined elegance
of the Jugendstil
towards a painting that
aims above all at
expression. The forms
are shaped out of
an eroded, scratched
paint. The figure rises
monumental in its
frontality, shifted
slightly to the right in
a tight space, almost
pushed flat against
the blue background.
Munch's interiors are
narrow and bare as
prisons. His figures
in these settings
have been compared
to fish in a bowl.

◆ PUBERTY
(1894, Oslo,
Nasjonalgalleriet).
A nude girl in a tight
space, a horizontal bed
cut off at each end by
the edges of the canvas
– a menacing shadow
grows out of her side
like death's dark wing.
Her staring eyes,
trembling body, and
gesture of modesty tell
of the girl's fragility.
With symbolic realism
Munch analyzes not so
much her adolescent
psychology –
"modelling for
the first time" –
who lives her first
sexual tremors
with a sense of guilt,
but an existential
condition, the passage
of a phase, and her
destiny already
marked by
the shadow:
this is the first trace
in art of the influence
of Kierkegaard.

THE FRIEZE OF LIFE

After his phase of Naturalism in Christiania, the encounter with Impressionism in Paris, and the Symbolist period in Berlin, Munch's pictorial idiom moved into a new phase, evolving towards the expression of mood. To concentrate better on his work, the artist chose certain special places, among them Åsgårdstrand, on the fjord of Oslo, a picturesque place imbued with an evocative, sunny atmosphere.

● In December 1893 the artist exhibited the canvas which he later renamed *The Voice*, with the title of *Love*; it became the initial core of his later *Frieze of Life*, and along with *Moonlight*, very similar in structure, shows his monumental conception of the picture and the transformation of the naturalistic model into a grand geometrical synthesis. The artist, who always based his exhibitions on a theme, from this time on conceives of his work as a stylistically and thematically organic whole. The *Frieze* summarizes fundamental moments of life, connected by the thread of a tragic intuition of existence. "I do not think that a frieze always has to present that monotony and unity which make pictures decorative and friezes so awfully boring… it can

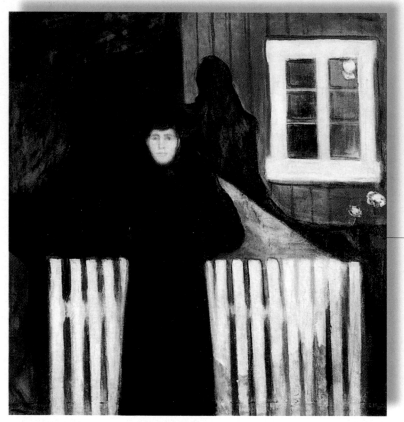

easily be made to have the same qualities as a symphony, which can free itself in the light and sink down toward the abyss. Its strength can be modulated."

● In 1902, at the Berlin Secession exhibition, Munch's pictures were arranged for the first time as a unified symphonic modulation on the same motif. That same year, the Vienna Secession presented Klimt's *Beethoven Frieze*, inspired by a joyous, optimistic view of life, at the opposite pole from Munch's.

● The *Frieze of Life* was installed along the four walls of the exhibition hall; the area on the left was given to *Love Awakening* (along with *The Voice, Red and White, Eyes in Eyes, Dance on the Beach, The Kiss,* and *Madonna*); *Love that Blooms and Fades* (composed of *Ashes, Vampire, The Dance of Life, Jealousy, Woman in Three Phases, Melancholy*) is on the wall facing the entrance; the right wall shows the theme of *Anguish* (represented by *Anguish, Evening on Karl Johann Street, Red Virginia Creeper, Crucifixion, The Scream*), and finally on the entrance wall is *Death* (with *Fever, Death in the Sickroom,* the Oslo version of *Girl and Death, Metabolism,* and the Bremen *Girl and Death*).

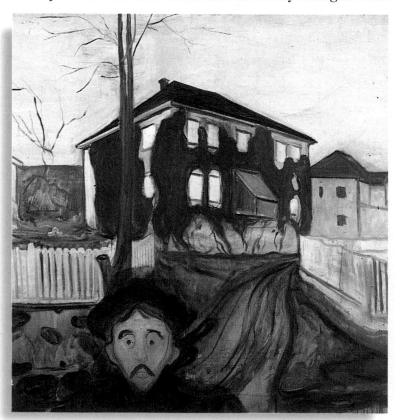

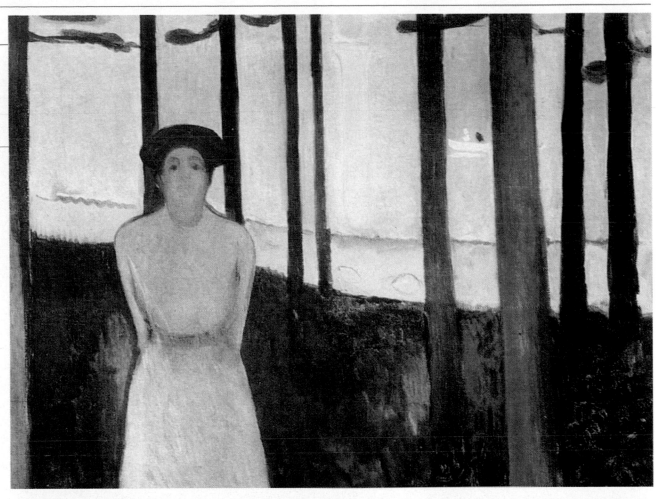

◆ THE VOICE
(1893, Boston, Museum of Fine Arts). The young woman reveals an ambiguous attitude, uncertain whether to offer herself to or pull back from the observer's gaze. With her off-center, monumental frontal position, she occupies the entire left part of the foreground.

◆ MOONLIGHT
(1893, Oslo, Nasjonalgalleriet). The position of the woman is the same as in *The Voice*, but the colors have been inverted. The dark shadow thrown against the house and the white fence are echoed in *The Voice* by the light outline of the "column of moonlight" and the dark trees marking off the rhythm of the picture.

◆ MOONLIGHT
(1895, Oslo, Nasjonalgalleriet). Compared to *The Voice*, here the woman is missing, but the "column of moonlight" has become the principal element of the painting. Munch's landscape, like that of the Romantics, is rife with symbols, but while the Romantics treat of life and death or patriotic themes, Munch gives it a sexual charge. The feminine element is here represented by water, while the male element is seen in the column of light of the moon.

◆ RED VIRGINIA CREEPER
(1898, Oslo, Munch Museet, left). The bright windows, standing out from the vines of Virginia creeper painted like a splotch of blood, are the protagonists of this picture. Munch scraped the paint to make them even more evident.

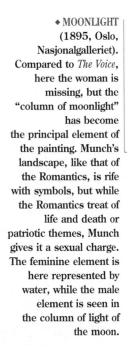

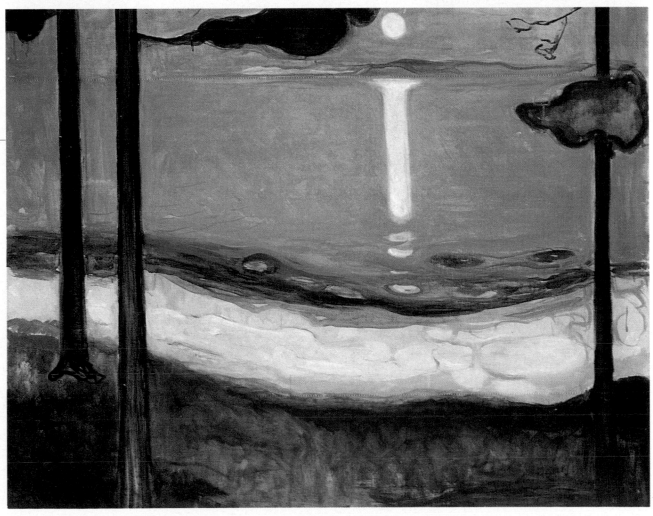

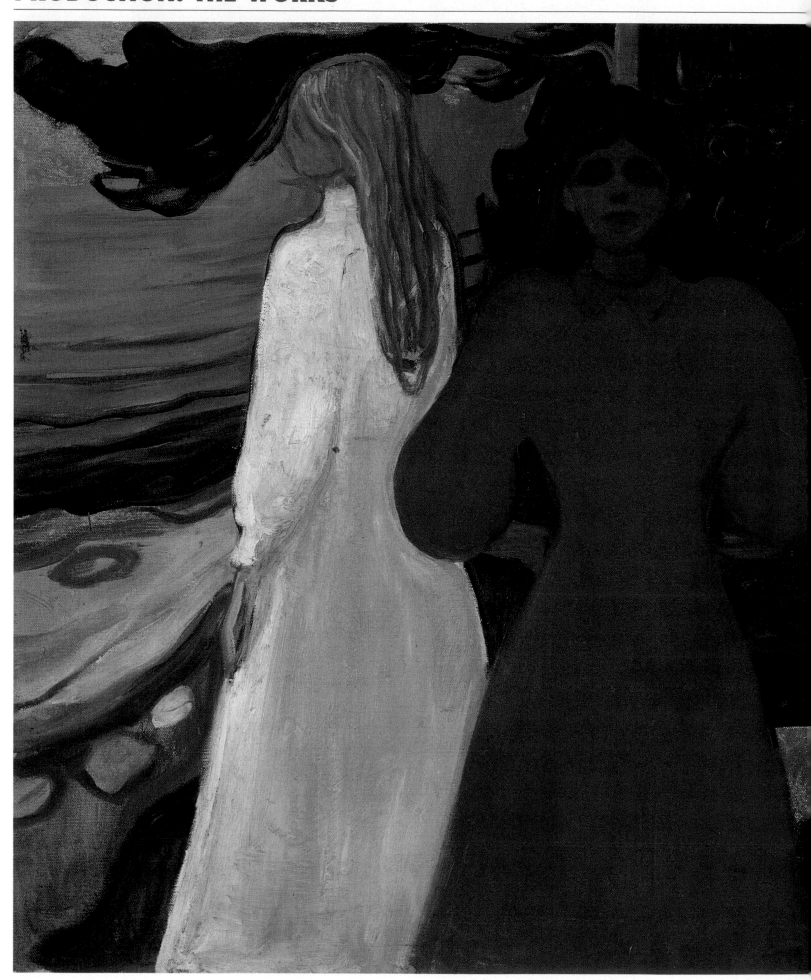

PRODUCTION: THE WORKS

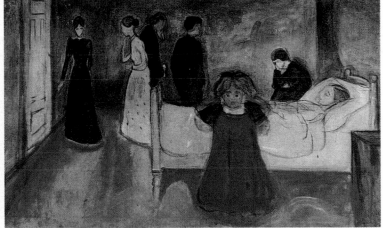

◆ RED AND WHITE
(1894, Oslo,
Munch Museet).
Once again we see
the woman in white
facing the water and
another placed frontally
in the same pose as
The Voice. The painting's
structure recalls *Woman
in Three Phases*, but gone
are the nude red-haired
woman and the man
among the trees.

◆ THE DEAD MOTHER
AND THE CHILD
(1897-99, Oslo,
Munch Museet).
The painting
belongs to
the *Frieze of Life*,
more specifically
to the speculation
on the theme of *Death*.
The picture evokes
the tragedy
of the death of Munch's
mother, at which he was

present along with his
sister Sophie, here
portrayed as the little
girl facing out
of the picture.
The artist gives an
admirable original
interpretation of life in
this small figure
dressed in red in
the foreground, in
contrast with the pale
horizontal bed,
the symbol of death.

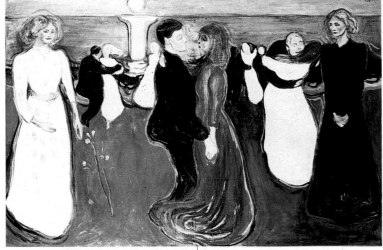

◆ THE DANCE OF LIFE
(1899-1900, Oslo,
Nasjonalgallieret).
In Norway the night of
the feast of St John,
the shortest of the year,
is celebrated with
outdoor dancing, which
Munch depicts in this
painting. Here he
attempts to express
the emotion of a memory
in the atmosphere
evoked by the relation-
ship of the shapes,
colors, and space.
It has been suggested
that the painting is

a narrative version of
Woman in Three Phases,
painted five years earlier.
This hypothesis is
supported by
the artist's own
description. "I was
dancing with my first
love, it was a memory
of her. The smiling
woman with blonde curls
arrives; she wants to take
away the flower of love,
but without allowing
herself to be plucked.
Passing over to the other
side, she appears
dressed in black as she

sadly watches
the dancing couple.
She is cut off from
the dance, just as
I was cut off from
her dance." The three
women are seen in
relationship to the man,
as in *Woman in Three
Phases*. Munch has
transformed the party
at Åsgårdstrand into
a ghostly ball. The man
with grotesque
features leaning over
the woman in white
on the right recalls
a mask by Ensor.

NORDIC MELANCHOLY

Man's solitude in the midst of the landscape is a recurrent motif in Romantic painting. Before Munch, only Friedrich had expressed with the same force and intensity the melancholy of isolation and the sadness of a fruitless wait.

● To the desolation of the person who

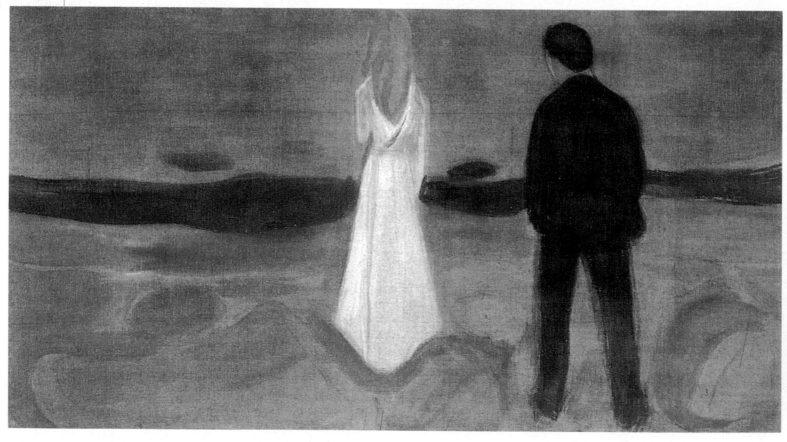

◆ CASPAR DAVID
FRIEDRICH
Woman at Sunset
(1818, Essen,
Folkwang Museum,
detail in oval).
The suspended
atmosphere rendered
by the German painter
with his figures seen
from the back underlies
many of Munch's
pictures, like *The Loners*
of 1906-07 (Essen,
Folkwang Museum,
below), part of
the *Reinhardt Frieze*.

submits defenselessly to the impossibility of finding his reflection in nature was given the name *Sehnsucht* by the German Romantics. It identifies the nostalgia of a condition that has been irreparably lost, an ingenuous, primitive state, a golden age when men were happy and free. Other Romantic motifs, too, appear in Munch's works, like the idea that the landscape reflects the moods of the artist who depicts it. Another frequent image in the work of Friedrich and Munch is man seen from the back as he observes the horizon with the artist's eyes.

● The German artist's canvases, however, lack the erotic tension which links the protagonists of Munch's works. The landscape, which is alive for both, in this context is no longer the mirror of mystical undefined yearnings, but instead of the turmoil of desire. The curved line of the shore in Munch's *Loners* runs through the picture and becomes a figurative space conceived as the junction of emotional contrasts. Thus in the painter's landscape the individual elements take on each time specific symbolic significance. The artist transfigures the Åsgård coast, simplifying the aspect of nature, which at the same time takes on a grandiose character.

◆ STARRY NIGHT
(1924-25, Oslo,
Munch Museet).
The landscape recalls
Starry Night
by Van Gogh, another
great loner.
In the foreground
stretches a dark
silhouette cast onto
the snow: the viewer or
the artist himself,
a prisoner of his
own shadow.

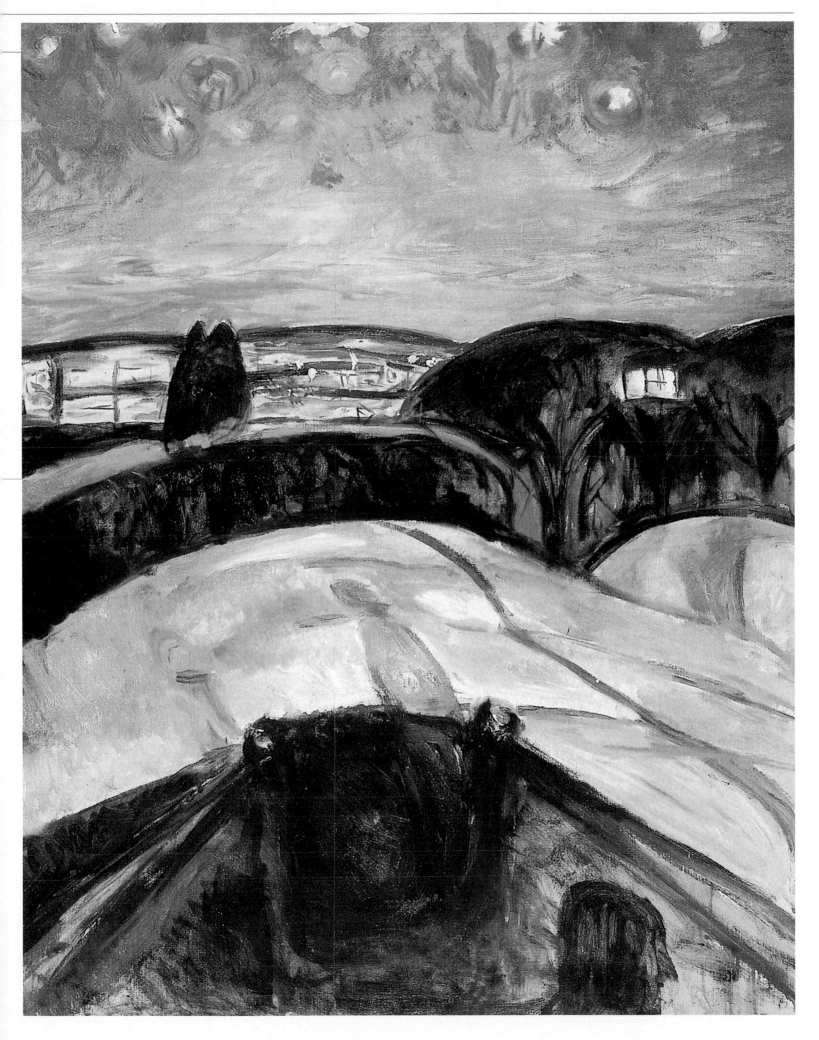

THE ETERNAL STRUGGLE OF LIGHT AND DARKNESS

Beginning in 1908, Munch's physical condition worsened, and after a number of crises aggravated by alcohol, he agree to enter one of the clinics in Copenhagen that he called "prisons for aristocrats of crime." Here, under the care of Dr. Jacobson, he wrote and illustrated his poem *Alpha and Omega*; as opposed to Van Gogh, illness did not keep him from working.

● Back in Oslo, Munch created his first open-air studio and set immediately to work on a fresco decoration for the Aula Magna of the University. The cycle, in the painter's words, represents the ideal continuation of his *Frieze of Life*: "The frieze shows the pains and pleasures of individual existence, seen without taking a distance from them; the University panels show the eternal universal forces." The first critical acclaim began to arrive.

● *Sun*, of 1909-11, is the symbol of the power of nature, of its reawakening after the darkness of winter – a theme deeply felt in northern countries – but also of the cathartic force which regenerates life –

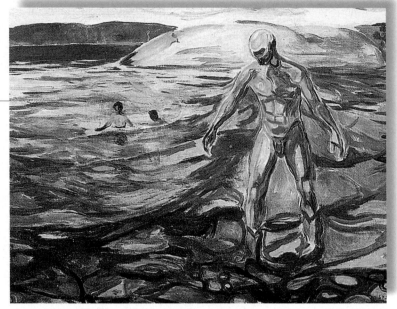

◆ BATHING MAN (1918, Oslo, Munch Museet). The work, which symbolizes the regenerating and cathartic power of water, shows the new direction taken by Munch's style after his recovery from his nervous crisis of 1908. The light color breaks up in myriad reflections and refractions, with a kaleidoscopic effect.

◆ SELF-PORTRAIT NEAR THE WINDOW (1940, Oslo, Munch Museet). The artist highlights the contrast between death – like the frozen nature which presses to come in through the window – and life – in the reds enlivening the face and wall.

with an autobiographical allusion to his complete recovery.

● His formal idiom changed as well: the Synthetism characteristic of Gauguin and the Nabis and recurrent in Munch's earlier work was now abandoned for a rapid brushwork that moves away from the broad zones of flat color. The dark palette linked to the tragic existentialist Symbolism now lightens; the contour lines, earlier clearly defined, blur, and the themes are no longer marked by tragic connotations.

◆ SUN (1909-11, Oslo, Aula Magna of the University). The central panel with the Sun, reflecting the new phase in Munch's art, was part of a decorative cycle with a symbolic, life-affirming inspiration.

● At the exhibition in Cologne in 1912, an entire room was reserved for Munch's work, as was the case for Cézanne and Picasso. The artist was celebrated by now as the precursor of Expressionism. Two great retrospective shows were organized in Berlin (in 1927) and Oslo. But official recognition did not stand up to the advent of Nazism. In 1937, in Germany, 82 works by Munch were taken out of museums and displayed at the exhibition of Degenerate Art. In 1940, after the outbreak of the war, Germany invaded Norway, and Munch shut himself up in his studio at Ekely, refusing all contact with the Germans.

◆ MURDERER (1910) Despite the fact that the artist had abandoned his tragic view of life, anguished visions sometimes emerged in his mind, as in this evocative picture, where the protagonist's face is reduced to a mask.

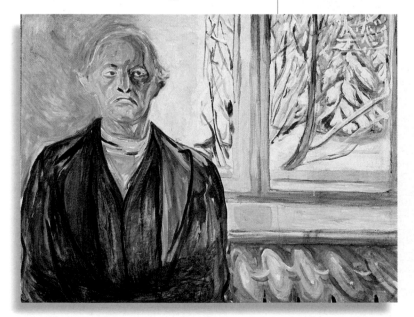

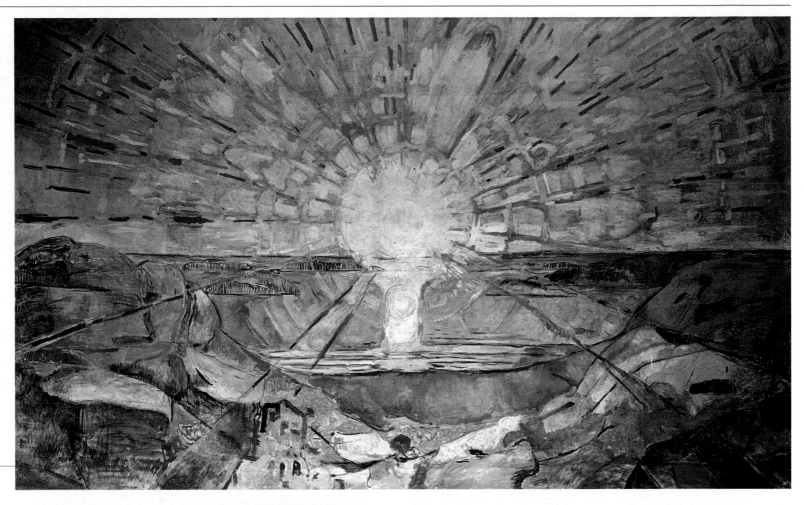

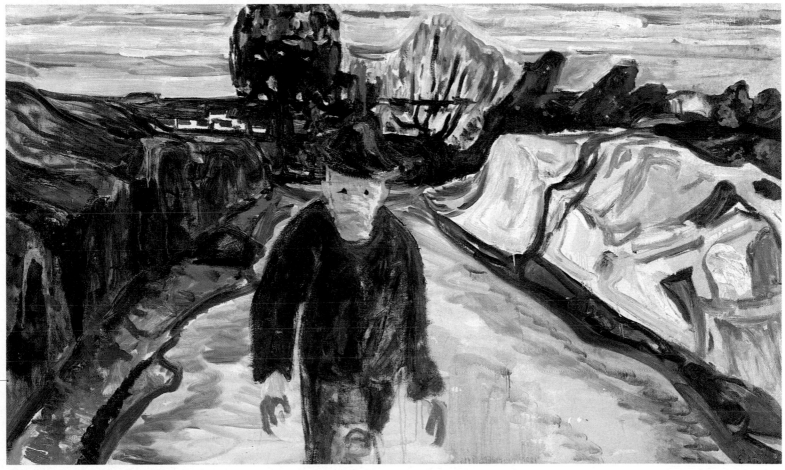

THE PAINTER AND THE MEN OF LETTERS

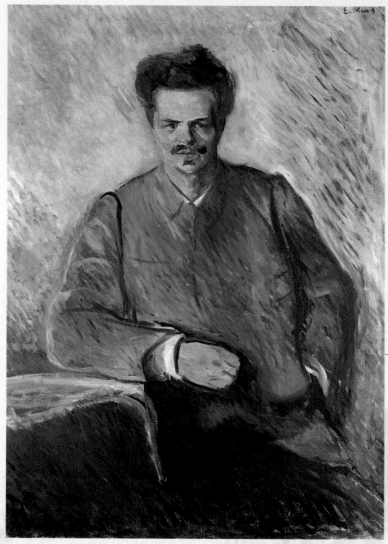

For Munch, his relationship with writers and intellectuals was a starting point, and Ibsen, Strindberg, and Hamsun were his literary interlocutors. Already at the age of 20 he knew the avant-garde world of the Naturalist painters and the "Christiania Bohème," as it was called in the homonymous novel by the anarchist writer Hans Jaeger, a follower of Zola. It is indicative of the cultural exchange that Jaeger, jailed for the ideas expressed in the novel, had Munch's *Madonna* hanging in his cell.

● The painter designed posters and stage sets for works by Henrik Ibsen, the playwright who embodied the anxiety and moral unease of the Norwegian bourgeoisie, and painted Ibsen

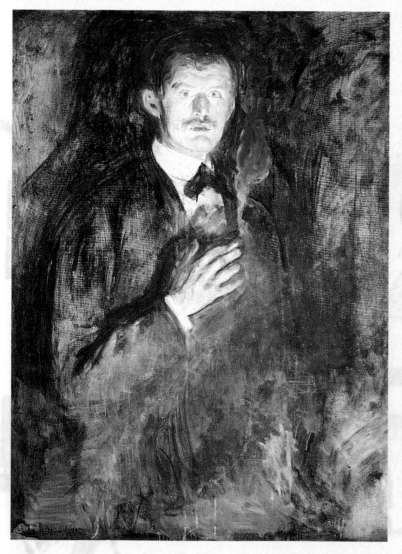

several times. In Berlin in 1892 a friendship began between Munch and Strindberg which introduced him into Paris literary circles. Strindberg wrote an essay on his painting on the occasion of his show at the Bing gallery. From him Munch learned a working method, using his own personal existential unease as a laboratory for daring artistic experimentation.

● Munch also became friends with the Danish poet Emanuel Goldstein (the seated figure in *Night at Saint-Cloud*). For him he created illustrations of the *Mandragora*, in which it is possible to discern the earliest ideas for representation of the theme of melancholy. Another Scandinavian talent who impressed the painter was the writer Knut Hamsun (1859-1952). The relationship with poets became even more profound when he illustrated the works of Baudelaire and Mallarmé, whose portrait he painted, to be placed ideally alongside those of Strindberg and Nietzsche.

◆ POSTER
FOR *PEER GYNT*
(1896).
The program, designed
by Munch for Ibsen's
play with music by
Grieg, reflects the work's
meaning: it represents
the aspirations of youth
which the experience
of life transforms
into searing
disappointments.

◆ PORTRAIT OF
FRIEDRICH WILHELM
NIETZSCHE
(c. 1905, Stockholm,
Thielska Gallery,
in the oval at left).
Nietzsche's theories
influenced Munch.
The artist met
the philosopher's sister
at Weimar in 1906.

◆ AUGUST STRINDBERG
(1892, Stockholm,
Moderna Museet).
The writer Ridberg's
comment on Strindberg,
made to a mutual friend,
is emblematic of
the playwright's
difference from other
people: "I can appreciate
a hooligan's genius,
but I don't want to have
anything to do with
the man."

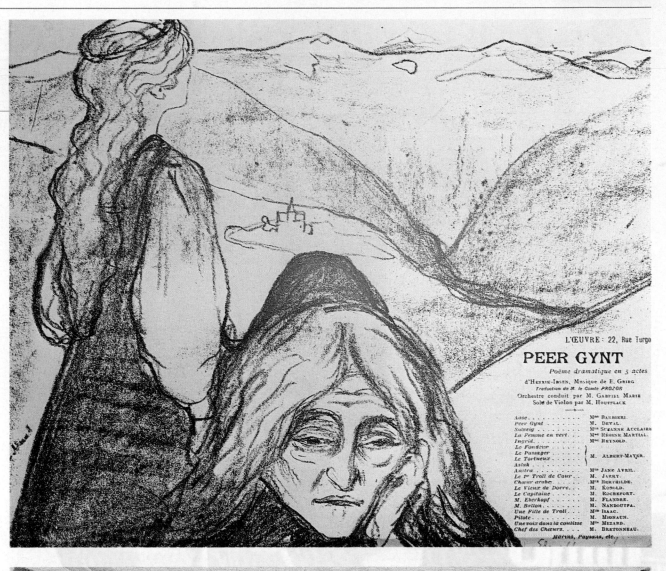

◆ STAGE SET FOR
IBSEN'S *GHOSTS*
(1906, Basel,
Kunstmuseum).
In 1906 the new
chamber theater
of Berlin was
inaugurated with
a performance of *Ghosts*.
Max Reinhardt, director
of the Deutsches
Theater, engaged Munch
to design the stage sets.

◆ SELF-PORTRAIT
WITH A CIGARETTE
(1895, Oslo,
Nasjonalgalleriet, at left).
For Munch the self-
portrait, just like the
diary, is an instrument
for investigating psychic
space as yet unexplored
artistically. The bluish
smoke envelopes
the figure, while
the white light strikes
only the hand and
the lost-looking face.

ART AND EXPRESSION

M unch's success and his enormous following can be explained by his deep penetration into the German art world. From Romanticism onwards, more and more artists worked autonomously, abandoning the practice of the workshop or studio of other masters, and Munch seems to have had no direct students; yet his art exercises an influence so strong as to determine the course of entire movements in painting. Simplifying schematically, it could be said that while Impressionism was born of French culture and of Positivism, Expressionism was born in the northern countries out of Romanticism and Symbolism, filtered through Naturalism: in a word, through Munch. "My first break with Impressionism was *Sick Child*: I was seeking expression," the artist declared.

● From the technical point of view as well, the Expressionists have to admit their debt to Munch. Emil Nolde, for example, undoubtedly owes what he calls "collaboration with nature" to the "horse cure." In 1909, after meeting Munch in Berlin, he too experimented with the procedure of letting the atmospheric elements act on the paint.

● In the sphere of Futurism, although the myth of progress, the automobile, and the city contrasts with Munch's poetics, Boccioni shows affinities with his art.

● The *Cobra* group, formed in Holland in 1949, had as its program a reproposal of Expressionism and pursued Munch's artistic research to its extreme consequences. Its protagonists – Corneille, Appel, Alechinschi, and Jorn – aimed at freeing art from society and tying it to the individuality of the gesture and to the material aspect of painting.

◆ ERNST LUDWIG KIRCHNER
Marcella
(1910, Stockholm, Nationalmuseum).
Marcella is one
of the most famous
Expressionist portraits.

◆ KAREL APPEL
A publication
of the *Cobra* group shows
Expressionism taken to
its farthest reaches.

◆ UMBERTO BOCCIONI
Portrait of Armida Brucky
(Verona, private collection).
The transfigured expression of feelings and the use of bright colors like the heavy purple and green shadows around the woman's mouth and eyes recall Munch's artistic research.

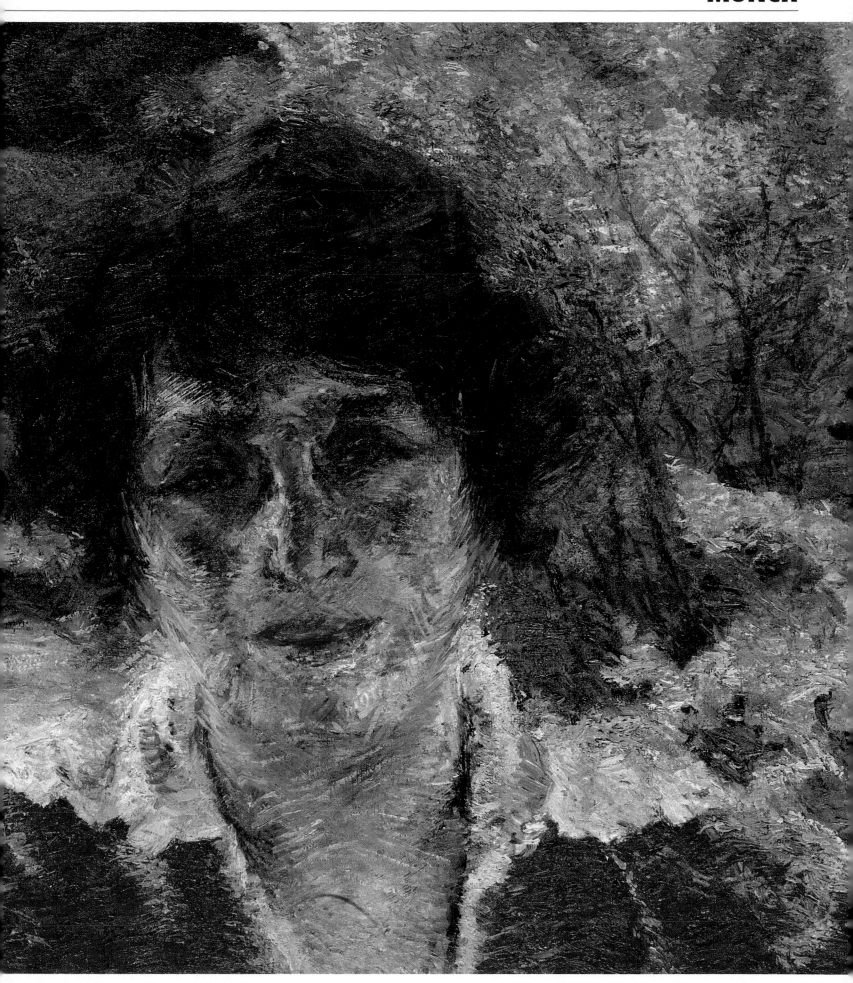

◆ PORTRAIT OF HIS SISTER INGER (1884)

The portrait, almost life-size, was shown at the Fall Show in Christiania in 1886. Despite its traditional layout, with the figure shown three-quarters length, wearing her black Confirmation dress, the work was criticized by the press, which called her a "repugnant Louise Michel" (the French anarchist suffragette), perhaps to strike at the youthful protest movement to which Munch belonged.

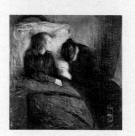

◆ THE SICK CHILD (1885-86)

Considered Munch's first masterpiece, the picture shows the maturity achieved in his themes of sickness and personal loss - in this evocation of his sister who died of tuberculosis - in both composition - a tight space occupied by half-figures - and technique: a heavily applied *impasto* then eroded and scratched. "Without fear and sickness my life would be a boat without oars," the artist stated.

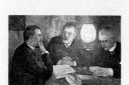

◆ JURISPRUDENCE (1887)

The young men, documented as belonging to the "Christiania Bohème" and active participants in Socialist demonstrations, are talking around a table. The picture was harshly criticized, perhaps for its too evident tie with groups who were fighting for a renewal of society and were, according to writers of the time, particularly vehement in their demands.

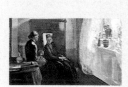

◆ SPRING (1889)

1889 was a decisive year for Munch: he became seriously ill and recovered in the spring, inspiring this painting. A faithful Naturalism in the representation of the subject – painted with a heavily laden brush – marks the left side of the picture, counterweighted on the right by an Impressionistic freedom and light colors in the natural elements and the wind blowing the curtain, symbolizing recovery.

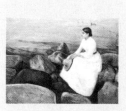

◆ SUMMER NIGHT (INGER ON THE BEACH) (1889)

This work announces the passage of Munch's art to a new aesthetic vision. One of his typical themes – a woman sitting in solitary, melancholy contemplation of nature – appears on his horizon. The only human traces are the traps behind her and the fishing boat. This painting, also criticized, was bought by the painter Erik Werenskiold (1855-1938).

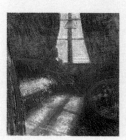

◆ NIGHT AT SAINT-CLOUD (1890)

The painting, perhaps inspired by Whistler's foggy nocturnes of London, is a gray and blue mist, but the spare, tight space still is firmly anchored by the perspective defined by the cross of the window frame and its sharp diagonal shadow on the floor. The profile silhouette of a figure wearing a top hat in the corner is the Danish poet Emanuel Goldstein.

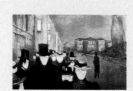

◆ RUE LAFAYETTE (1891)

The picture, painted in Paris from Munch's rented room at 49 Rue Lafayette, clearly shows the influence of Impressionism – which he would later call a "brush fire" – in its light colors and detached brushstrokes. Its structure, with the balcony railing in perspective and the figure of the observer, prefigures the layout of works like *The Scream* and *Desperation.*

◆ EVENING ON KARL JOHANN STREET (1892)

The main street of Christiania, with a perspective view of the three wings of the Parliament building, the Stortinget, is Munch's setting here. The figures moving forward like a flood are cut off at the bust or waist to give an unsettling effect of nearness which emotionally involves the viewer. The painter shows the bourgeoisie of the city promenading like a procession of ghosts.

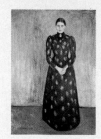

◆ PORTRAIT OF HIS SISTER INGER (1892)

The portrait presents the already codified image of a sad woman wearing a bell-shaped skirt, her hands clasped in front of her, which would be repeated in Munch's most famous paintings counterbalancing a figure in white representing fate and a presage of death. Compositionally, the stiff, monumental figure, portrayed frontally, is set slightly off-center.

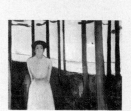

◆ THE VOICE (1893)

The painting is the ideal fulcrum of the *Frieze of Life*, a composition made up of a series of thematically and stylistically united panels which treat of love, life, and death. The woman in the foreground, monumental in her frontality and placed off-center, shows an ambiguous attitude somewhere between modesty and boldness, an ambivalence typical of the women in Munch's work.

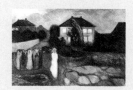

◆ THE STORM (1893)

An actual event which took place that year on the Norwegian coast gave the artist the starting point for a portrayal of a human condition. The woman in white is separated from the group standing outside. Here again is Munch's code gesture for a refusal of pain, clapping one's hands over one's ears. The lighted windows take on particular symbolic significance in this context, and the artist has scraped the paint layer to heighten the brilliance of their light.

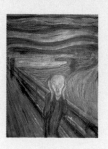

◆ THE SCREAM (1893)

This painting is part of the *Frieze of Life*, which was assembled completely for the first time at the Berlin Exposition in 1902, the same year that Klimt's *Beethoven Frieze* was presented at the Vienna Secession. The friezes, which are similar in their formal treatment, inspired by musical composition, reveal opposite conceptions of love, which brings salvation for Klimt, and for Munch is fatal.

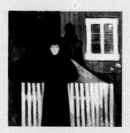

◆ MOONLIGHT (1893)

The brown house may be the fisherman's cottage Munch bought in Åsgårdstrand. Standing in front of the fence is a woman whose bell-shaped skirt is reduced to a black silhouette. Her position is the same as in *The Voice*, but the colors are reversed. This same inversion is echoed in the dark shadow on the house and the white fence, corresponding to the bright "column of moonlight" and the dark trees.

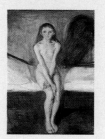

◆ PUBERTY (1894)

The theme of "love's awakening" is frequent among the Symbolist painters: examples are Gauguin's *Loss of Virginity* or Bernard's *Madeleine in the Woods*. The eggplant-shaped shadow emerging from the girl's side represents her future. Merely in her body language, her arms crossed over her pubic area, her eyes staring wide, the young girl reveals her fragility in the face of her awakening sexuality.

◆ THE NEXT DAY (1894-95)

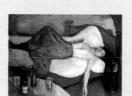

The setting is quite similar to *Puberty*: there is the same tight space, the same shades of ochre and brown. The decadent theme of the mystique of the prostitute is another common one in turn-of-the-century art; good examples are Toulouse-Lautrec and Degas. But here Munch crudely narrates the moment of abandon and not the triumph of carnality, and his pessimistic outlook pervades the scene.

◆ ASHES (1894)

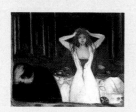

The work belongs to the *Love that Blooms and Fades* section of the *Frieze of Life*. In a theatrical setting, a crouching man is the picture of desperation, while just to the right of center is a standing woman (who resembles Milly Thaulow) in a white slip with her legs apart. Her hair tangles around the man's back. In the foreground a fallen trunk is turning into ashes.

◆ WOMAN IN THREE PHASES (SPHINX) (1894)

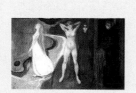

This is Munch's major work on the theme of woman. The three figures show the various concepts of femininity present in the artist's mind: the woman on the left is a sea nymph; the nude figure, representing a prostitute, is a portrait of Dagny Juell Przybyszewska; the third woman, who stands for affliction, has the facial features of Inger and of Milly Thaulow.

◆ MOONLIGHT (1895)

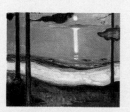

The painting shows the same landscape as *The Voice* and the same artistic transfiguration of the Åsgårdstrand beach, but in place of the woman the white reflection of the "column of moonlight" rises as a sexual symbol. "The trees and sea are," in Munch's own words, "vertical and horizontal lines… the bright colors produce an echo that resounds through all the paintings."

◆ MADONNA (1894-95)

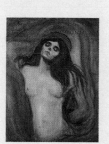

Munch's most famous painting besides *The Scream* associates the idea of love and sex with divinity. Stylistic and thematic affinities can be seen with northern European Symbolist works like *Sin* (1893) by Von Stuck and *The Sleeper* (1900) by Max Klinger. The monumental transfiguration of the body, pushed outwards toward the viewer, is seconded by the almost geometric simplification of some of its parts.

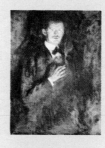

◆ SELF-PORTRAIT WITH CIGARETTE (1895)

The painting shows affinities with the *Portrait of the Painter Gerhard Munthe* by Krohg, of 1885, depicted in the same pose in an Impressionistic rendition. But while Krohg uses the cigarette to characterize his sitter socially, Munch foregoes a description of the background to use the smoke, which seems to rise out of the person himself, to frame and highlight the figure and his hand.

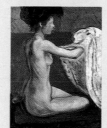

◆ PARISIAN NUDE (1896)

The painting shows evident thematic and iconographical affinities with *The Toilette* by Toulouse-Lautrec or *After the Bath* by Degas, both of the same year. As opposed to these artists, Munch abolishes all narrative indications: the setting is spare, and only a white cloth contrasts with the red of the wall. The thick, heavily laden brushstrokes have lost all connotations of Impressionism.

◆ THE DANCE OF LIFE (1899-1900)

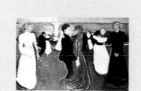

The couples dancing as though in a trance in the foreground are counterpoised by those frantically coupling in the back. On the right, the face of a dancer leaning over his partner stands out, his grotesque features similar to those of masks by Ensor, another northern European artist who ferociously criticized the bourgeoisie. The composition's rigid symmetry is broken by the "column of moonlight."

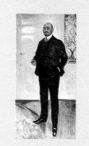

◆ PORTRAIT OF WALTER RATHENAU (1907)

In the early years of the century, Munch painted a series of portraits; this is the most important. The sitter, a well-known industrialist and the son of the founder of AEG in Berlin, later said of himself: "A disgusting sort, don't you think? This is what happens when you have your portrait painted by a great artist: you become similar to what you are." The painting shows the imposing figure standing with legs apart, his head thrown arrogantly back.

◆ LONERS (1906-07)

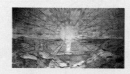

The panel is part of a frieze commissioned by Max Reinhardt, director of the Deutsches Theater of Berlin, to decorate the "Bohnensaal" ('bean room') on the first floor. Its most salient novelty is its technique: tempera on unprimed canvas, well suited to the eroded paint layer favored by Munch. Powerful brushstrokes outline the figures to make them visible from their high position.

◆ SUN (1909-11)

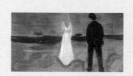

This is the panel for the front wall of the Aula Magna at the University of Oslo. Inserted, like others by Munch, in a cycle, the picture testifies to a new cathartic and regenerative vision of art after his hospitalization in Copenhagen in 1909 because of recurrent nervous crises. "The university paintings represent the strength of outside forces," the artist stated about his 11 monumental canvases.

◆ SELF-PORTRAIT NEAR THE WINDOW (1940)

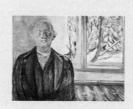

The structure of this picture, based on vertical and horizontal lines, represents the contrast between the upright and supine position, between life and death. The dialectic is reproposed between the bright colors on the left and the muted tones on the right, between the warmth indoors and the cold outside. The window motif, a favorite of Munch's, recalls the iconography typical of Flemish painting.

TO KNOW MORE

The following pages contain: some documents useful for understanding different aspects of Munch's life and work; the fundamental stages in the life of the artist; technical data and the location of the principal works found in this volume; an essential bibliography

DOCUMENTS AND TESTIMONIES

Strindberg's Hell

In Hell *(1896), the autobiographical novel by the great Swedish writer Johan August Strindberg (1849-1912), an intimate friend of Munch, a brief but meaningful dialogue takes place in front of a portrait with bones which Munch painted of his friend the writer Przybyszewski in 1895. The author lucidly describes the picture's meaning: it is a "memento mori," which is an iconography typical of the Counter-Reformation, taken up again in the second half of the nineteenth century by northern European artists like Arnold Böcklin, Hans Thoma, and Louis Corinth.*

"Let's save our friend at least in a literary sense. I shall do an article on his gifts as a writer, you will paint a fine portrait, and we'll offer them both to the *Revue Blanche.*
In the Danish artist's studio – the dog is no longer on guard! – we look at a two-year-old portrait of Przybyszewski. It is only a head cut off by a cloud, and below, dead men's bones like in funerary monuments. The chopped-off head gives me the shivers, and the dream I had on May 13 haunts me like a ghost.
- How did you get the idea of a beheading?
- It's hard to say, but something fatal was looming over that subtle spirit, who already possessed a certain sham genius and aspired to supreme glory, without wanting to pay the price. Life offers only this choice: laurels or pleasure.
- Oh, so you've finally found that out?"

[A. Strindberg, *Inferno*, 1896]

The sounds of color

The musicality of color and line is a characteristic element of Munch's art, one that in a certain sense still ties him to Symbolism, even though he goes beyond the rhythmic musicality of the line in Art Nouveau to look for a sonorousness expressed mainly in "shouted" colors. The painter Christian Krohg, Munch's teacher and friend, highlights this aspect of his art in the following passage.

"The long beach curves in the painting to end in a harmonious line. This is music. Gently carved out, stretching below above the calm water, with little discreet interruptions, are the roof of a house and a tree, of which the painter very skillfully has omitted suggesting even a single branch, because this would have ruined the line. Out on the still water is a boat parallel to the horizon – a masterful repetition of the line in the background. We have to thank Munch that the boat is yellow; if it had not been yellow, he never would have painted this picture [...] Has there ever been anyone who heard sound in color as here in this painting?"

[C. Krohg, 1891]

On the boulevard in Christiania

The Norwegian writer Knut Hamsun (pseudonym of Knut Pedersen) (1858-1952), in his novel Hunger *of 1890, shows numerous points of contact with themes close to Munch's heart. His description of the hour of the promenade along the main street of Christiania recalls the painting* Evening on Karl Johann Street, *of 1892.*

"The sun was in the south, it was about twelve o'clock. The city started to grow lively, it was approaching time for the promenade; people, smiling and greeting, moved in waves back and forth along Karl Johann. I pulled my elbows tight to my side, made myself as small as possible, and managed to pass unseen by some people I knew who were standing on a corner near the university watching whoever passed by. I walked along up the hill to the castle and gave in to my thoughts. [...] What was wrong? Had the finger of God pointed to me? But why me? Why not somebody else, some man in South America for example? [...] I walked and thought about this and could not free myself of this thought, I found the most irrefutable arguments against this decision of God to make me pay the penalty for everyone's sins."

[K. Hamsun, *Hunger*, 1890]

Angel and demon

Henrik Ibsen (1828-1906), in his 1899 play When We Dead Awaken, *treats the impossibility for the artist of reconciling art with life. He takes the inspiration for his protagonist Irene from* Woman in Three Phases *(or* Sphinx*), Munch's painting of 1894. In a note in his* Diaries *Munch reports a conversation with the writer. In another passage he writes that he identifies with the figure of the sculptor Rubek, among Ibsen's characters, and recognizes in Irene, who symbolizes the impossible dream of art, the girl dressed in white in his painting.*

"Rubek: Our love is certainly not dead, Irene!
Irene: The love that we knew on earth... on this glorious, marvelous, enigmatic earth, is dead in us both!
Rubek: It's that very love ... that is burning in me now stronger than ever!
Irene: But in me? Have you forgotten who I am now?
Rubek: It doesn't matter. For me you are the woman I've seen in my dreams.
Irene: I have stood naked on stage: after leaving you I have shown my body to hundreds of men.
Rubek: And to think that I was the one who pushed you to this! Blind, as I was then, I put an image of dead clay before the happiness of life... the happiness of love."

[H. Ibsen, *When We Dead Awaken*, 1899]

HIS LIFE IN BRIEF

1863. Edvard Munch born on December 12 in Löten, Norway, the son of Christian Munch, a military doctor, and Laura Catherine Björstad. His brothers and sisters were Sophie, Laura, Inger, and Andreas.

1864. The family moved to Christiania, now called Oslo.

1868. His mother died of tuberculosis.

1879. Enrolled in a technical school to study engineering.

1880. Decided to devote himself to painting.

1881. Enrolled in the Royal School of Drawing, studying under the painter Christian Krohg.

1883. Participated in the Fall Show – where he would exhibit regularly from this moment – in Christiania. Painted *en plein air* in Modum, under the guidance of Frits Thaulow. Became part of the "Christiania Bohème."

1885. First study tour to Paris, thanks to a grant. Upon return to Christiania, started three of his major works: *The Sick Child, The Next Day,* and *Puberty.*

1886. Exhibited *The Sick Child* at the Fall Show in Oslo, to fierce criticism.

1889. First one-man show held in Christiania, exhibiting 110 works to critical acclaim. Began summering in Åsgårdstrand, which would become his summer home. Returned to Paris in October, where he enrolled in Léon Bonnat's art school. His father died in November. Moved to the Paris suburb of Saint-Cloud. *The Saint-Cloud Manifesto* marked his break with Naturalism.

1890. Continued at the art school; in May returned to Christiania, where he won a second state grant. In November left for France; contracted rheumatic fever in Le Havre, spending two months in the hospital.

1891. Spent January in Nice, April in Paris, on Rue La Fayette, returning to Norway in May, where he won his third state grant. Returned to Nice in the fall and worked on motifs for the *Frieze of Life.* In December a fire destroyed five of his paintings. Painted *Melancholy.*

1892. Spent the summer in Norway; did not exhibit at the Fall Show. Participated in the exposition of the Union of Berlin Artists, closed because of violent protest. The scandal helped make Munch famous in Germany.

1893. In Berlin was in contact with the group of the magazine *Pan.* Worked on the *Frieze of Life* and *The Scream.*

1894. Made his first color lithographs. The first monograph on his work published.

1896. Went to Paris, where he exhibited lithographs and woodcuts.

1897. Exhibited in Paris at the *Salon des Indépendants* 10 canvases from the *Frieze of Life.* In June organized a one-man show at S. Bing's gallery "L'Art Nouveau," reviewed by Strindberg for the *Revue Blanche.*

1899. After several trips through Europe returned to Norway, where he spent the fall and winter in a sanatorium.

1900. Traveled in Italy; finished *The Dance of Life.*

1902. Exhibited at the Berlin Secession the *Frieze of Life,* made up of 22 canvases. Met Max Linde, who bought his paintings and wrote an essay about him. Dramatically ended his relationship with Tulla Larsen.

1903. Painted the Linde family portrait. Met the model Eva Moducci.

1904. Exhibited 20 canvases at the Berlin Secession.

1906. Painted sketches for the stage sets for Ibsen's *Ghosts* and *Hedda Gabler.*

1908. Painted *Stonemason and Shop Worker,* the first in a series dedicated to the world of work. In Copenhagen, a more serious nervous crisis than his earlier ones forced him into the hospital.

1909. While hospitalized, wrote *Alpha and Omega,* illustrating it with 18 lithographs. Returned to Norway in May.

1911. Won the competition for the fresco decorations of the Aula Magna at the University of Oslo.

1912. Exhibited in a collective show in America.

1916. Bought a house at Ekely, near Oslo.

1818. Wrote a pamphlet on the *Frieze of Life.*

1927. A large retrospective of his work held in Berlin and then Oslo.

1930. A broken blood vessel in his right eye made him partially blind and kept him from working.

1937. In Germany, 82 of his works were removed from museums and shown at the exhibition of Degenerated Art organized by the Nazi regime.

1940. Donated his works to the city of Oslo. Germany invaded Norway. Munch refused all contact with the Germans.

1944. Died January 23 in Ekely.

WHERE TO SEE MUNCH

The following is a catalogue of the principal works by Munch conserved in public collections. The list of works follows the alphabetical order of the cities in which they are found. The data contain the following elements: title, dating, technique and support, size in centimeters, location.

BERGEN (NORWAY)

House in Moonlight,
1895; oil on canvas, 70x95.8;
Rasmus Meyer collection.

Woman in Three Phases (Sphinx),
1894; oil on canvas, 164x250;
Rasmus Meyer collection.

Melancholy,
1894-95; oil on canvas, 81x100.5;
Rasmus Meyer collection.

Nude Seen from the Back,
1894; oil on wood, 49.5x 65;
Rasmus Meyer collection.

Landscape Near Nordstrand,
1891; oil on canvas, 59.4x73.3;
Rasmus Meyer collection.

Girl Combing her Hair,
1892; oil on canvas, 91.4x72.3;
Rasmus Meyer collection.

Evening on Karl Johann Street,
1892; oil on canvas, 84.5x121;
Rasmus Meyer collection.

BERLIN (GERMANY)

Two Girls,
1892; tempera on unprimed canvas, 90x70;
Nationalgalerie SMPK.

BOSTON (UNITED STATES)

The Voice,
1893; oil on canvas, 87.5x108;
Museum of Fine Arts.

ESSEN (GERMANY)
Loners,
1906-07; tempera on unprimed canvas, 89.5x159.5;
Folkwang Museum.

NEW YORK (UNITED STATES)
The Storm,
1893; oil on canvas, 91.5x131;
Museum of Modern Art.

OSLO (NORWAY)
Self-portrait with Cigarette,
1895; oil on canvas, 110.5x85.5;
Nasjonalgalleriet.

Ashes,
1894; oil on canvas, 120.5x141;
Nasjonalgalleriet.

Moonlight,
1893; oil on canvas, 140.5x135;
Nasjonalgalleriet.

Moonlight,
1895; oil on canvas, 93x110;
Nasjonalgalleriet.

The Dance of Life,
1899-1900; oil on canvas, 125x190.5;
Nasjonalgalleriet.

The Sick Child,
1885-86; oil on canvas, 119.5x118.5;
Nasjonalgalleriet.

The Scream,
1894; oil, tempera, and pastels
on cardboard, 91x73.5;
Nasjonalgalleriet.

The Next Day,
1894-95; oil on canvas, 115x152;
Nasjonalgalleriet.

Madonna,
1894-95; oil on canvas, 91x70.5;
Nasjonalgalleriet.

Mother and Daughter,
1897; oil on canvas, 135x163;
Nasjonalgalleriet.

Night in Saint-Cloud,
1890; oil on canvas, 54x64.5;
Nasjonalgalleriet.

Parisian Nude,
1896; oil on canvas, 80.5x60.5;
Nasjonalgalleriet.

Spring,
1889; oil on canvas, 169x263.5;
Nasjonalgalleriet.

Puberty,
1894; oil on canvas, 151.5x110;
Nasjonalgalleriet.

Girls on a Bridge,
1899; oil on canvas, 136x126;
Nasjonalgalleriet.

Portrait of his Sister Inger,
1892; oil on canvas, 172x122.5;
Nasjonalgalleriet.

Rue Lafayette,
1891; oil on canvas, 92x73;
Nasjonalgalleriet.

Self-portrait: the Man Who Walks at Night,
1923-24; oil on canvas, 90x67.5;
Munch Museet.

The Kiss,
1897; oil on canvas, 99x81.5;
Munch Museet.

The Dead Mother and the Child,
1897-99; oil on canvas, 104.5x179.5;
Munch Museet.

The Death of Marat I,
1907; oil on canvas, 151x260;
Munch Museet.

Military Music in the Street,
1923-24; oil on canvas, 90x67.5;
Munch Museet.

Sun,
1909-11; wall decoration, 452.5x788.5;
Aula Magna of the University.

LÜBECK (GERMANY)
The Four Children of Dr. Max Linde,
1903, oil on canvas, 144x199.5;
Museum für Kunst und Kulturgeschichte.

BIBLIOGRAPHY

Most of the writings by Munch are in the Munch Museet in Oslo. For further study of the periods characterizing his artistic development, the general catalogues of Munch's works should be consulted.

1894 S. Przybyszewski, *Edvard Munch*, Berlin

1907-28 G. Schiefler, *Verzeichnis des Graphisches Werke Edvard Munch*, Berlin

1963 B. Degenhart, "Munch," in *Enciclopedia Universale dell'Arte*, X, Florence

1966 E. Hüttinger, *Edvard Munch*, Milan

1973 *Edvard Munch Probleme, Forschungen, These*, edited by O. Busch, Munich

1974 R. Stang, *E. Munch*, Oslo

1975 T.M. Messer, *E. Munch*, New York

1979 R. Stang, *E. Munch*, Oslo, London

1983 A. Eggum, *E. Munch*, Oslo (Milan, 1985)

1984 R. Heller, *Munch, his Life and Work*, London

1986 U.M. Schneede, *Edvard Munch, Das kranke Kind,* Frankfurt

1987 *Lumières du Nord. La peinture scandinave 1885-1905*, Paris

1990 U. Bischoff, *Edvard Munch*, Cologne

1994 E. di Stefano, *Munch*, in *Art Dossier,* no. 96, Florence